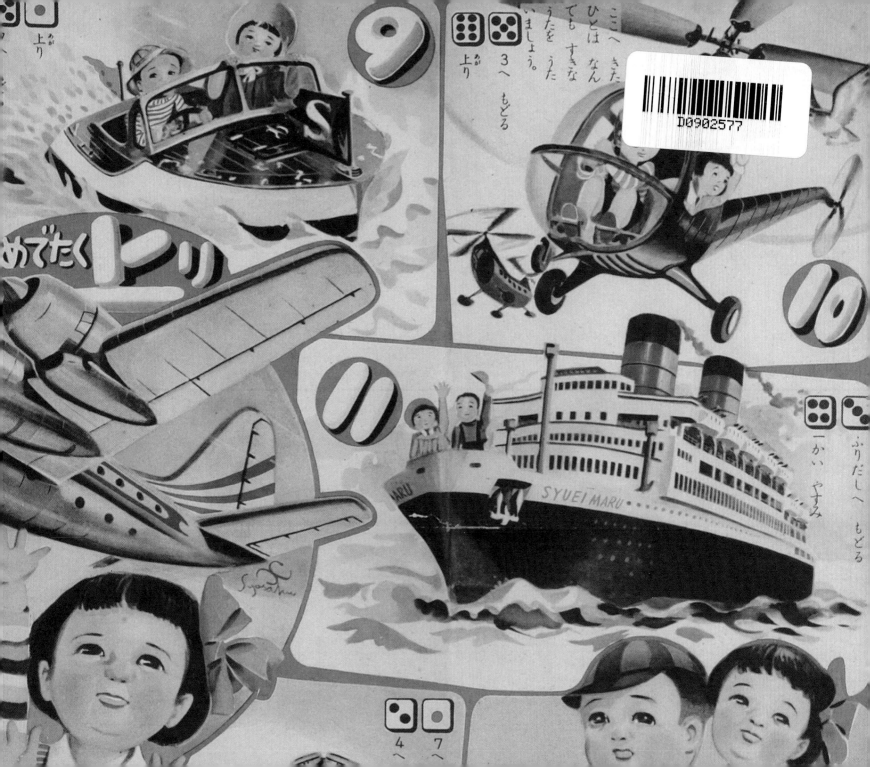

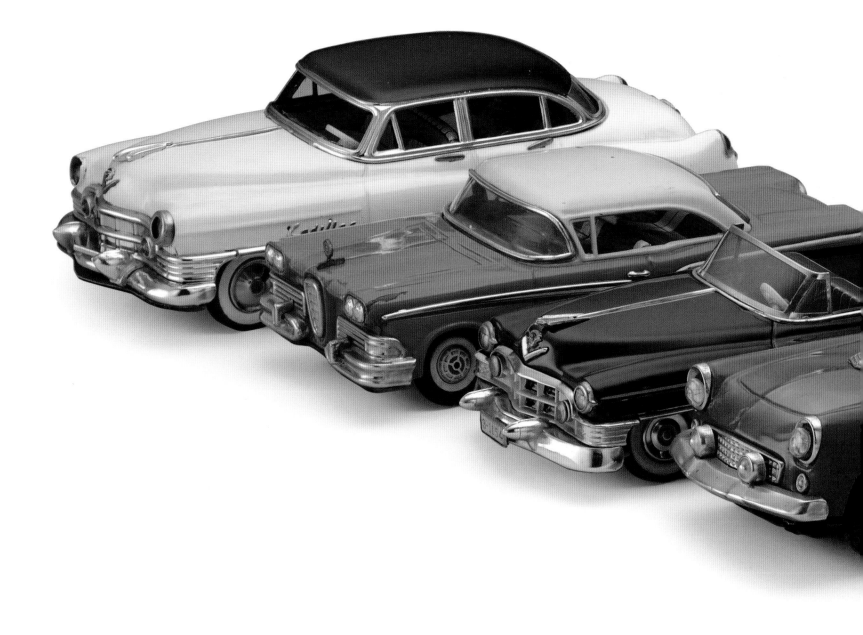

BURIKI

JAPANESE TIN TOYS FROM THE GOLDEN AGE OF THE AMERICAN AUTOMOBILE: THE YOKU TANAKA COLLECTION

JOE EARLE

Published by

JAPAN SOCIETY

New York

Distributed by

YALE UNIVERSITY PRESS

New Haven & London

This volume accompanies the exhibition *Buriki: Japanese Tin Toys from the Golden Age of the American Automobile, The Yoku Tanaka Collection* at Japan Society Gallery, New York, July 9–August 16, 2009.

Japan Society gratefully acknowledges the support of Nippon Steel U.S.A., Inc.

Media sponsorship for this exhibition is provided by LOUISE BLOUIN MEDIA

Transportation assistance is provided by JAPAN AIRLINES

Exhibitions at Japan Society are also made possible in part by the Lila Wallace-Reader's Digest Endowment Fund and the Friends of the Gallery. Installations at Japan Society Gallery are supported by a generous gift from Henry Cornell.

Japan Society also wishes to thank The W. L. S. Spencer Foundation for its catalogue support.

Edited by Melanie B. D. Klein
Designed by Jonathan Glick

Printed and bound by Lotus Printing, China

Most of the toys shown in this book, and the prototypes from which they were derived, may be covered by various copyrights, trademarks, and logotypes. All rights are reserved by their respective owners.

ISBN: 978-0-300-15157-2

Library of Congress Control Number: 2008937550

Distributed by Yale University Press for Japan Society

Yale University Press
302 Temple Street
P.O. Box 209040
New Haven, CT 06520-9040
www.yalebooks.com

JAPAN
SOCIETY
Japan Society Gallery
333 East 47th Street
New York, NY 10017
www.japansociety.org

CAPTIONS TO ENDPAPERS
FRONT: *Norimono sugoroku* (*Board Game with Vehicles*), supplement to *Yoi ko no tomo* magazine, vol. 26, no. 10 (January 1, 1951), published by Shūeisha. The Cadillac Sedan (square 7) and the Boeing Stratocruiser (central circle) both resemble toy models featured in this catalogue (see cats. 3–8, and 57).

BACK: *Norimono sugoroku* (*Board Game with Vehicles*), early 1950s, publisher unknown. The bus (square 2) and the Cadillac Sedan (square 5) both resemble toy models featured in this catalogue (see cats. 27 and 3–8).

Contents

Foreword

Motoatsu Sakurai
President, Japan Society

In recent years, our programs at Japan Society have often highlighted mutual influences between Japan, Europe, and the United States. This exhibition enriches the narrative of this three-way cultural and commercial interaction by introducing a little-known facet of Japan's economic revival sixty years ago. Having already competed successfully with a European country—Germany—as a producer of high-quality toys during the 1920s and 1930s, after World War II Japanese manufacturers were quick to spot the export potential of high-quality miniature replicas of American automobiles.

We are very grateful to Mr. Yoku Tanaka for sharing his extraordinary collection with our visitors. As well as entrusting some of his finest miniature masterpieces to us, Mr. Tanaka has been generous with his time and knowledge. We owe an additional debt of gratitude to Mr. Tanaka's friends and helpers, Ms. Akemi Narita and Ms. Michiko Okunishi, for all their assistance in preparing the collection for its journey to the United States, and for their help in compiling this publication.

Exhibitions at Japan Society Gallery would not be possible without the Lila Wallace-Reader's Digest Endowment Fund. *Buriki* in particular has received sponsorship support from Nippon Steel U.S.A., Inc., our whole visual arts program benefits from the ongoing generosity of Chris A. Wachenheim, and this publication is subsidized by a major three-year grant from Jack and Susy Wadsworth through The W.L.S. Spencer Foundation. We are indebted to Japan Airlines for their ongoing and critical help with transportation, and to our media partners, WNYC New York Public Radio and Louise Blouin Media.

Special mention should also be made of the more than sixty Director's Circle and Gallery Circle Friends of the Gallery, whose consistent support and encouragement are vital to the realization of our long-term goals.

In 1952—the very same year that the Marusan Company was preparing to launch its superb Cadillac toy—John D. Rockefeller 3rd, then President of Japan Society, wrote of Japan Society's mission to serve " . . . as a medium through which both our peoples can learn from the experiences and the accomplishments of the other." I am delighted that Mr. Tanaka has given us the opportunity to further that mission in such a unique manner, and I congratulate him on the realization of his long-cherished wish to see his collection displayed in an American institution.

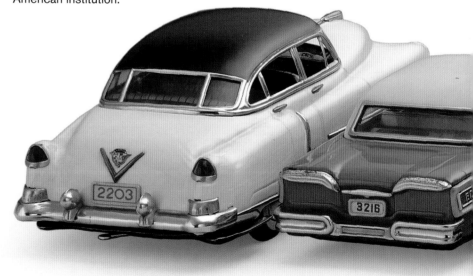

NOTE TO READERS

All the toys featured in this catalogue are from the collection of Yoku Tanaka; the photographs are by Tadaaki Nakagawa.

Every effort has been made to correctly identify the manufacturers, makes, models, and dates of the American automobiles whose toy versions are reproduced here. Because of differences in the production cycles of real cars and toy cars, however, the toymakers' versions sometimes feature characteristics copied from more than one model year (for example, 1956 trim on a 1955 body). In the case of simpler, less expensive toys, the absence of fine detail can make it difficult to identify more than the manufacturer and make.

Each caption gives the name of the original American vehicle (if there was one) and its recorded dates of manufacture, followed by any special features of the toy; the toy's dimensions and the toy company's name (if known), in its shortest form and in Japanese where possible; and the toy's dates of production (if known). It should be noted, however, that many of the most prolific companies—such as Nomura and Alps—did not actually make anything themselves, but instead coordinated the activities of several small independent contractors.

There are few available data concerning the dates of the toys themselves, but it is likely that, in most cases, they were put on sale about a year after the actual automobiles were unveiled. Some toys seem to have remained on the market for several years after the original car model was discontinued.

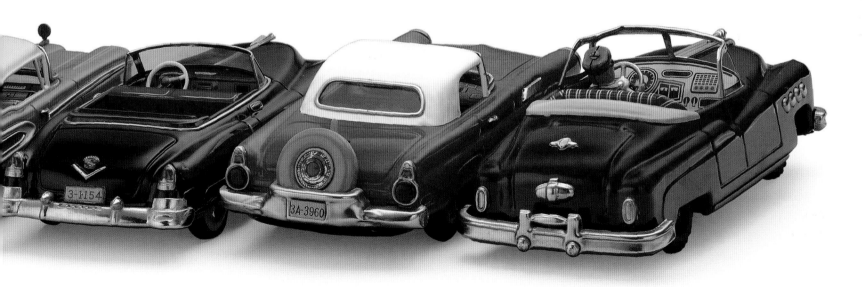

Collecting Japanese Tin Toys
Yoku Tanaka

was born in Tokyo in 1944, and when I was about seven or eight years old, one of my aunt's acquaintances—an employee at a U.S. military base—used to call at our house in an American car, which he parked with a flourish right in front. The moment they caught sight of this marvel, the local children would crowd around, gazing at it with a mixture of envy and wonder. I still remember the time I was given a ride around the neighborhood with a group of my friends. The car somehow seemed so roomy and comfortable! I've loved American automobiles ever since.

I started collecting when I was in junior high school, and I'll never forget the fun I had comparing stamps, coins, or whatever else was in fashion with my schoolmates, in between classes or at the end of the day. Those stamps and coins are still sleeping quietly in a corner of my house. My collection got going in earnest when I was seventeen years old. On my way home from high school I'd drop into a bookstore in the Shinbashi district of Tokyo, and next door I found another place that sold miniature die-cast cars and plastic models. That was in 1961, when such things still couldn't be found in department stores or regular toy stores. I can still recall how excited I was to see them. I would stand there for hours, oblivious to the passage of time, transfixed by the serried ranks of foreign model cars. They all cost far more than I could afford with just my pocket money, but with the cash I earned helping out at my father's delicatessen or doing part-time work at the post office, I managed to purchase one of them every month. Little by little I put together a collection of American and European cars selected from toy catalogues. I'd line them up at home and loved nothing more than just enjoying them on my own. As the collection slowly grew, I purchased display cases and arranged my treasures in them by type. Several years went by, but I never grew tired of gazing at them.

When I went to college I got to know other collectors. We would visit each others' houses, sharing information, showing off our latest acquisitions, and thinking up ways of making our collections more complete. Thanks to a friend's introduction, I was able to join a model-car collectors' club. Meetings at the club gave me the opportunity to look at many amazing examples that I hadn't come across before, including discontinued lines and other pieces that had never been commercially imported into Japan. I quickly realized that my own collection still had a long way to go. Spurred by my innate competitive streak, I began to exchange cars with foreign collectors, sending them Japanese-made examples the moment they were produced, and in return receiving discontinued products from overseas manufacturers. As soon as each package arrived I would open it in a state of high excitement, just as I still do today. Gradually my collection grew more complete, and every time I identified a new type that appealed to me, I would make friends with other enthusiasts who shared my interest. I was particularly keen on extending my collecting beyond passenger cars to include public vehicles such as

buses, police cars, and fire trucks, improving my knowledge by studying specialist magazines, and putting all my energy into acquiring pieces that other people did not own.

Around the time I left college and started work, the first specialist model-car stores began to open, selling older toys that were no longer being made. The restaurant that I managed was doing pretty well and I got more and more interested in collecting, so much so that I had to fit out a special room to house my treasures. The stores that sold die-cast models then started to sell older, larger tin-toy cars. At first I wasn't that keen on them, but one day I went to look at a friend's collection and was amazed by the quality of the Japanese examples he had on display. That night, I was so excited I couldn't sleep. At last I realized that I should focus on tin-toy cars, and then I devoted my efforts to acquiring them. I painstakingly combed through all the specialist toy stores in Tokyo, sometimes going into their warehouses and buying entire inventories of unsold stock, but even that wasn't enough for me. Using a map to plan my trips, I methodically visited other cities, tourist centers, and towns that had grown up around old castles, temples, and shrines. It was about this time that the first big toy fairs were held throughout Japan, and collectors everywhere began moving away from miniature die-cast cars in favor of larger tin models. Dealers from all over Japan, America, and Europe would exhibit at the fairs, and huge numbers of collectors would descend on their display stands, filling the halls to capacity. This was the peak of the tin-toy craze: prices almost doubled in a single year. American and Japanese cars, robots, and cab-behind-engine buses were the most popular. When the most

influential dealers opened their displays, crowds of collectors would gather around in expectation, struggling to get hold of the most appealing pieces. Thanks to this enhanced level of interest, I managed to acquire examples of nearly all the best American models—so many of them, in fact, that a sizeable space was needed to show them all together. Over time my holdings gradually grew to include not only automobiles but also airplanes, ships, working vehicles, and every other variety of tin toy. Finally, I moved on to acquiring Japanese-made tin toys from the prewar era. The moment I got into prewar toys, there was no limit to my enthusiasm. Just recently they have become virtually unobtainable—you could even say that I'm the last of the prewar-toy collectors.

As in every collecting field, there are once-in-a-lifetime buying opportunities that can never be repeated, no matter how much cash you have at your disposal. I'm very lucky to have been able to form my own collection at such a perfect moment. This exhibition does not feature prewar material, but one day I would like to put my prewar collection on view for everyone to see. There were two great peaks in the history of tin-toy manufacture in Japan, one before World War II and one after it. For the present show I have focused on the second of those peaks, Japanese-made tin-toy models of 1950s American cars. I do hope you will appreciate the immense technical skill that went into the creation of these faithful reproductions from the Golden Age of the American Automobile, and I would like to thank Japan Society for giving me the opportunity to display my collection in New York.

From Kosuge's Jeep to the Marusan Cadillac

Joe Earle
Director, Japan Society Gallery

The first Japanese toys made of tinplate, or *buriki* (derived from the Dutch *blik*), were produced about a century and a quarter ago by local manufacturers spurred by the success of imported German train and boat models. Although they have a certain charm, these early emulations of toys from an industry in which Nuremburg then reigned supreme are fairly rudimentary. Miniature warships celebrating Japan's victory over Russia in 1905, for example, consist of no more than a few simply lithographed sheets of metal that were bent—rather than hand- or machine-pressed—into the required shapes, and embellished with only the most basic details. Starting around 1914, however, Japanese manufacturers took advantage of the international crisis to more than triple their overseas sales, aided by the introduction of sophisticated manufacturing machinery and better clockwork technology. By the end of World War I, Japan had assumed a dominant position in the global toy industry. Coupling traditional metalworking skills with imported technology, Japanese tinplate toys, in particular, earned a worldwide reputation for quality and detailed workmanship over the next two decades.

All of this came to a temporary halt in July 1940, when the government issued a proclamation banning the use of metal for anything other than the war effort. Just before the ban, a successful toy designer and toolmaker named Matsuzō Kosuge had created an ingenious performing-seal toy that descended a slope holding a revolving parasol; but now he was forced to switch his production to camera components, and later even had to evacuate his Tokyo factory and move it to the town of Ōtsu, near Kyoto. Following Japan's unconditional surrender in August 1945, however, Kosuge lost no time in returning to his former trade, using empty food cans discarded by the Occupation forces. He had the cans cleaned out with caustic soda and hammered flat to form rough plates, which were first cut into the required shapes and then bent and assembled to make a model of an American jeep, with the inside of the can forming the outer surface of the toy. "Kosuge's Jeep," as it came to be known widely, was only a few inches long, sold without a box, crudely hand-painted with the U.S. Army star on its hood, and powered by nothing more than an elastic band.

Not long before Christmas 1945, this little toy—nowadays a considerable rarity—was offered for sale at the Marubutsu Department Store in Kyoto at the giveaway price of ten yen, making it affordable even to impoverished Japanese buyers. Hundreds were snapped up in the first hour, giving Kosuge the confidence to expand production (with the help of local female labor) and increase the price to thirty yen. Accounts of the number of Jeeps sold by the end of the year range from ten thousand to one hundred thousand, but whatever the exact figure, it is clear that Kosuge had struck gold through an ingenious combination of recycled materials, simple technology, and a brilliant choice of vehicle. As historian John Dower has observed, the U.S. Army Jeep "was appropriate, for the child's world was defined, in generally positive and

uncritical ways, by an acceptance of the fact of being occupied." Racing around the devastated streets of Japan's cities "like pet mice," Jeeps were new, ubiquitous, and symbolic of American friendliness and munificence: "'Hello,' 'good-bye,' 'jeep,' and 'give me chocolate' were the first English words most youngsters learned," and many children's cartoons of the time depict GIs in Jeeps fraternizing with Japanese children.[1]

Although Kyoto and its environs had escaped wartime bombardment, the Asakusa and Honjo districts of Tokyo—traditional centers of the Japanese toy industry—were flattened by air raids in the first half of 1945. Kosuge's success, however, was enough to spark a revival of toy manufacture in the capital. From December 1945 to January 1946, a toy exhibition was held in Ueno Park, and in the first weeks of 1946 a Tokyo factory managed to begin production of a sedan car. Based on a German model, this sedan was a little more sophisticated than the Jeep, which seems to have been made without the use of a hand- or power-press. The sedan had a pressed body with roof and sides and was driven by a spring, but like the Jeep, at four inches long it was still far smaller than the toy cars that would dominate the high-end American market in the 1950s and early 1960s. Despite the imposition of a sixty-percent sales tax, fifty thousand units were sold in January, and a total of five hundred thousand units by the end of October 1946. The Occupation authorities were well aware of the past reputation of the Japanese toy industry, and viewed it as a sector of the economy that could—and should—be brought up and running quickly. Beginning on August 15, 1947, Japanese toy makers were ordered to export much of their production, helping both pay for vital imports (such as rice) and meet a severe

shortage of toys in the United States. More than half of all metal toys produced went overseas, their foreign sales rising from under eight million yen in 1947 to more than eight *billion* yen in 1955.[2] This rapid success owed much to the inexpensive repurposing of machine presses that had earlier been converted from toy to munitions manufacture, low labor costs, and simple innovations (such as better friction-driven motors); but an even more important part was played by the manufacturers' flair in adapting their products to a new market. Although this book is devoted to toy vehicles, it is interesting to note that as early as the late 1940s, "Newsboy," a doll made by Nikkō, "with a celluloid head and a body built from tin cans, was clearly designed for an American audience. All the written script . . . was in English, and the doll's torso was draped in the Stars and Stripes."[3]

Two Cadillac toys, the earliest pieces illustrated here (cats. 1 and 2), are rare survivals from this fledgling phase of Japan's postwar toy industry. Their small size and rudimentary trim contrast strongly with the dimensions and detail of later toy Cadillacs, but they are made accurately enough for the original 1947 and 1949 automobile models to be identified with some confidence, using reference works compiled not for toy collectors, but for classic American automobile enthusiasts. The earlier car's rear-wheel housing—retained until 1947—follows prewar styling, while the later 1949 model has the typical Cadillac profile that persisted until the mid-1950s. This accuracy would be greatly enhanced in the early 1950s with a wealth of fine detail and gleaming chrome trim, which served two different but overlapping purposes. Carefully modeled, readily identifiable toy cars appealed, on the one hand, to prosperous America's expectation that its real automobiles should be restyled ever more glamorously year

after year; and on the other hand, to struggling Japan's sense of wonder at the sheer wealth and brashness of its giant former enemy. This *akogare* (yearning), recalled in the first paragraph of collector Yoku Tanaka's Introduction, is tellingly captured in two simple board games that form the endpapers to this book, with Japanese children riding every type of American vehicle, including Jeeps, Cadillacs, racing cars, and buses. It can also be glimpsed in the scenes on many toy boxes (for example, cat. 52) that depict prosperous families, blessed with ample leisure time, speeding through America's "great outdoors."

Although the two early Cadillacs bear only the mandatory "Made in Occupied Japan" mark, it is perhaps not too far-fetched to speculate that they were manufactured by the Marusan company, a pioneering business founded in 1947 whose history throws light on the enterprising spirit of those difficult immediate postwar years.[4] Established in 1923 as the Ishida Factory, the company originally made spectacles and cheap cameras. In 1933 it was taken in a new direction by the founder's son, Haruyasu Ishida, who changed the name to Marusan and began manufacturing optical toys. Like many other enterprises in the 1930s, Marusan was gradually forced to switch its production to military needs before it was totally destroyed in the 1945 Tokyo air raids. Haruyasu and his younger brother Minoru, along with another relative, managed to resume business in 1947, operating at first as a wholesale company but later developing their own products (using the best possible recycled materials) and relying chiefly on exports to the United States. Around 1950, the company's product range included a small friction car, assorted dolls and animals, a helicopter, a tank, a fire engine, and a very popular " . . . windup Lucky sewing machine with a celluloid girl behind the machine."[5] It was then that Minoru Ishida embarked

on an ambitious project to produce a metal automobile with realistic proportions, colorful lithographed upholstery, and finely crafted metal details, both metaphorically and literally outshining the simple models of the previous four or five years, and setting the standard for the next decade. The car he chose to copy was the latest Cadillac sedan (cats. 3–5), then the most desirable and iconic of American automobiles; but with no reference materials to work with, Ishida had to rely on photographs he took of examples he saw on the streets. Like many other toy companies throughout the 1950s, Marusan did little manufacturing itself, instead coordinating the efforts of a large number of subcontractors, starting with the craftsmen who created the wooden models needed to build press molds for the car bodies. To manage the entire process and ensure that the Marusan Cadillacs would meet the highest standards, Ishida recruited none other than Matsuzō Kosuge, of Jeep fame.

A rare surviving photograph of Kosuge's workshop helps us to appreciate the labor-intensive, under-capitalized character of toy manufacture at the time. While larger components such as the bodies, which required the use of a heavy-duty press, were probably produced by factories that normally specialized in other industrial goods, many of the fifty-four smaller components were pressed and tooled by hand in family-size workshops. The parts were finally put together under Kosuge's direct supervision by employees at his own factory, most of them female, shown here working on a kind of miniature assembly line with the most finished toys furthest from the viewer. Marusan was among the first companies to use real chrome for details such as the all-important Cadillac crest, which—like the other components—was first lithographically printed, then pressed, then fixed by tiny tabs into slots on the car's body. This was very much a "screwdriver plant," and a

Toy-car factory (probably the Toriumi factory, run by Matsuzō Kosuge), about 1953. Photo courtesy Marusan Toys, Inc.

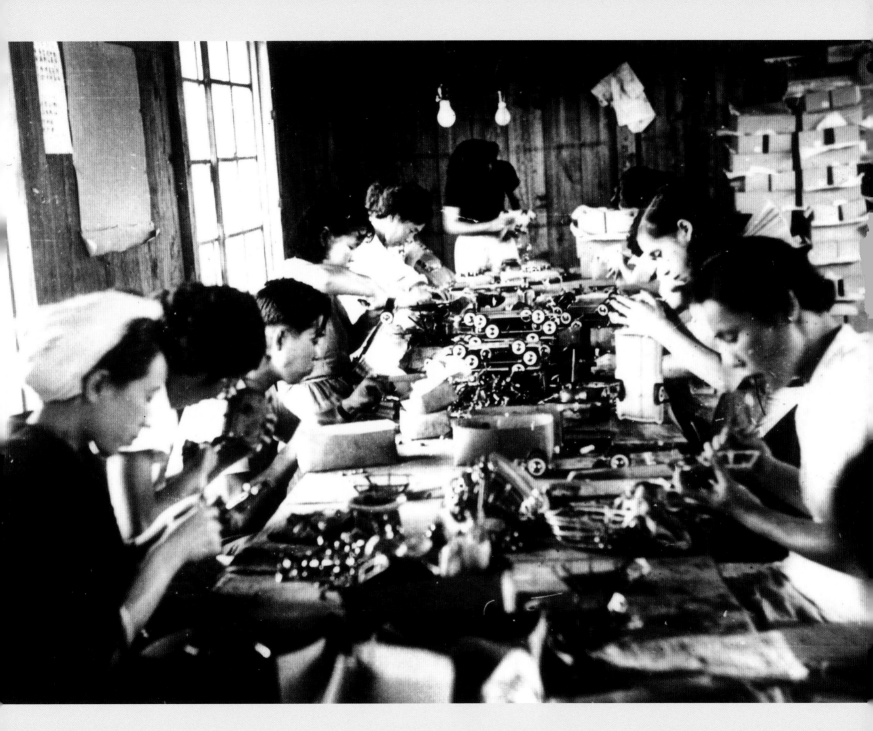

colleague of mine, brought up in Japan in the 1950s, recalls driving his parents to distraction by reversing the assembly process, easily taking his toy cars apart using a miniature toolkit given to him by a well-meaning relative!

Between 1949 and 1951, problems with quality had damaged the toy industry's reputation, but by the time of the Marusan Cadillac's launch in 1953—after three years of development work—these had been resolved, thanks to the establishment of a manufacturers' association whose approval was required before any toy could be exported. Priced at two dollars in American department stores, the Cadillac was an instant success on account of its large size (just over a foot long), striking realism, and wide range of colors. Sales were also bolstered by the introduction of different versions featuring such novelties as electric (instead of friction) motors and battery-powered lights. By Christmas 1954, the shops of Washington, D.C. were crammed with inexpensive Japanese toys that were crowding out their American equivalents, long before real Japanese automobiles began to flood world markets in the 1970s and 1980s. The

General Motors Buick Roadmaster
Two-Door Sedan, 1953;
construction kit with battery-powered lights.
7 ½ x 7 ⅛ x 2 ½ in. (19 x 18 x 6.5 cm).
Marusan Shōten, about 1954.

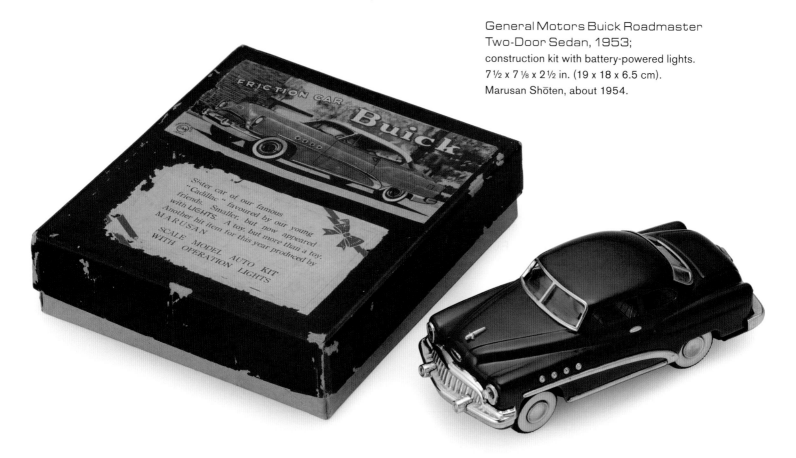

Marusan Cadillac was also put on sale in Japanese department stores for fifteen hundred yen, the first toy of its kind—according to the company's own account—to breach the one-thousand-yen level. Although we have no record of the advertising used in Japan to sell this extravagant plaything that was intended mainly for the United States, a later Marusan toy gives us an interesting glimpse into the different promotional strategies adopted for high-quality, high-price toys in two different markets. Building on the success of the Cadillac, about 1954 Marusan brought out a smaller construction-kit version of a Buick Roadmaster (cat. 16; facing page), with English-language text on the box that extols it as "Sister car of our famous "Cadillac" favoured by our young friends. Smaller, but now appeared with LIGHTS. A toy, but more than a toy. Another hit item for this year produced by MARUSAN." A second example of this toy has a Japanese-language label that boasts, "This Buick . . . is currently being exported to department stores throughout North and South America and Australia, where it easily outsells similar products from Germany and Britain. The makers have taken every possible step to ensure this model gives children and young people the feel of a real Buick."[6] While the product itself communicated American glamour and styling, Marusan judged that it could also be sold to Japanese parents by appealing to patriotic pride in their country's export prowess. Even so, most tin toys continued to be made for export.

This selection from the Yoku Tanaka collection takes the story of Japanese tin-toy cars (and a few other vehicles, real and imaginary) through the mid-1960s; five to ten years later, nearly all of the more than a dozen toy companies named in the captions had gone out of business, overwhelmed by competition from plastic. Yet despite its inevitable victory on grounds of cost and even safety, plastic could never approach the sense of the "real thing" that is conveyed by a large, beautifully crafted, late tinplate masterpiece such as Asahi's 1962 Chrysler Imperial (cat. 67). Not only were the cars' bodies formed in power-presses, just like those of their full-size counterparts, but most of the details were still made from lithographed, painted, and chromed tinplate that closely resembled the original materials. Better yet, the use of hand-applied details made it possible to partially restyle toys from year to year without the need for completely new molds. Even if this practice sometimes compromised the quest for total accuracy, it gave Tokyo's toy factories the flexibility to react quickly to design changes in Detroit's car plants, and helped them create a charming miniature chronicle of the Golden Age of the American automobile.

1 John Dower, *Embracing Defeat: Japan in the Wake of World War II* (New York: W.W. Norton and Company, 1999), 110; Ryōsuke Saitō, *Shōwa gangu bunkashi* (*Toy Culture in the Showa Era*) (Tokyo: Jūtaku Shinpōsha, 1978), 176.

2 Saitō, *Shōwa gangu bunkashi*, 187, 191.

3 Anne Allison, *Millennial Monsters: Japanese Toys and the Global Imagination* (Berkeley and Los Angeles: University of California Press, 2006), 38–39.

4 Anon., "Marusan Kyaderakku sutōrii" (The Marusan Cadillac Story), in Akinori Shirai, ed., "Kitahara Teruhisa korekushon no sekai" (The Teruhisa Kitahara Collection), *Antiku toisu* (*Antique Toys*), Geibun Mooks, no. 586 (May 2008): 67–79.

5 Marusan-USA, ed., "Marusan History," http://www.marusan-usa. com/2295.html (accessed January 2, 2009).

6 Teruhisa Kitahara and Yukio Shimizu, *1000 Tin Toys* (Cologne, Lisbon, London, New York, and Paris: Taschen, 996), 596–97.

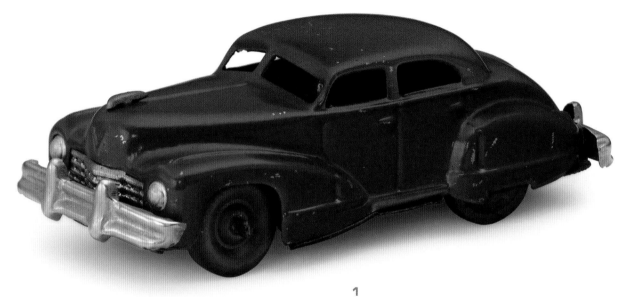

1
General Motors Cadillac 62
Four-Door Sedan, 1947;
marked *MADE IN OCCUPIED JAPAN*.
5 ⅛ x 2 x 1 ¾ in. (13 x 5 x 4.5 cm).

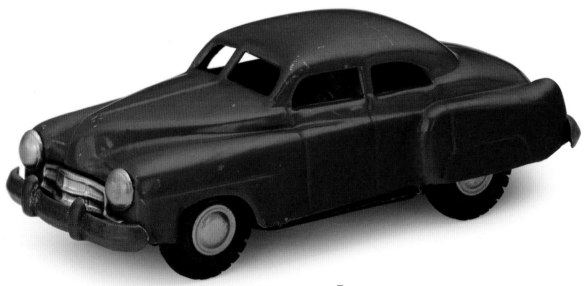

2

General Motors Cadillac 62
Four-Door Sedan, 1949;
marked *MADE IN OCCUPIED JAPAN*.
5 1/8 x 2 1/8 x 1 3/4 in. (13 x 5.5 x 4.5 cm).

Beginning on August 15, 1947, the Supreme Command for the Allied
Powers permitted Japanese toys to be exported, provided that they
were clearly marked *MADE IN OCCUPIED JAPAN*. Although these two
rare survivals must date from between 1947 and 1952, when the
Occupation ended, it is not possible to determine their exact date. Of a
type known to toy collectors as "fat cars," they are much more detailed
than the celebrated "Kosuge's Jeep" that was such a hit in 1945 (see
p. 10), but their construction is still very simple by comparison with the
Marusan Cadillacs that were produced from 1953.

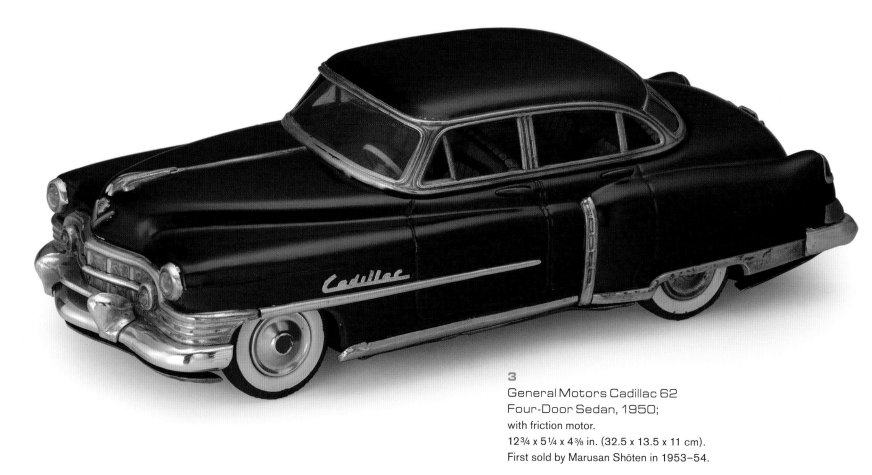

3

General Motors Cadillac 62
Four-Door Sedan, 1950;
with friction motor.
12¾ x 5¼ x 4⅜ in. (32.5 x 13.5 x 11 cm).
First sold by Marusan Shōten in 1953–54.

This is an outstandingly well preserved example of the detailed, painstakingly made Cadillac models that were produced by the Marusan company under the overall direction of Matsuzō Kosuge (see pp. 12–13). They came in both friction- and battery-driven versions and in a range of colors, including black, gray, gold, red, white, and—for the battery models—a combination of cream and dark green.

4

General Motors Cadillac 62
Four-Door Sedan, 1950;
with friction motor.
12¾ x 5⅛ x 3⅞ in. (32.5 x 13 x 10 cm).
First sold by Marusan Shōten in 1953–54.

Despite the meticulous styling of these early
Marusan Cadillacs, there is still some debate
surrounding the exact model they were
intended to emulate. One theory holds that
the illustrations on the boxes (not reproduced
here) showed the 1951 60 Special Sedan,
while the toys themselves are based on the
1950 62 Sedan. As these were the first truly
realistic toy automobiles made in Japan after
World War II, it is perhaps not surprising that
it took so long to put them on the market.

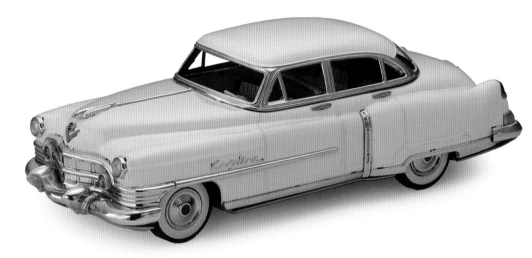

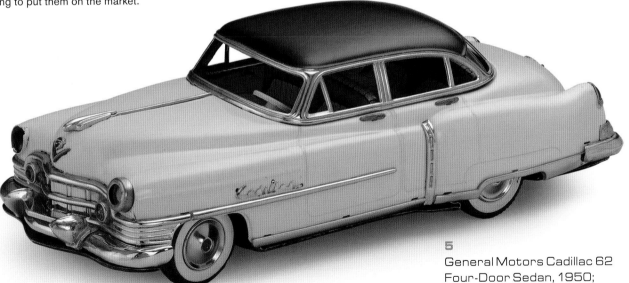

5

General Motors Cadillac 62
Four-Door Sedan, 1950;
with battery-powered motor.
13 x 5¼ x 4 in. (33 x 13.5 x 10 cm).
First sold by Marusan Shōten in 1953–54.

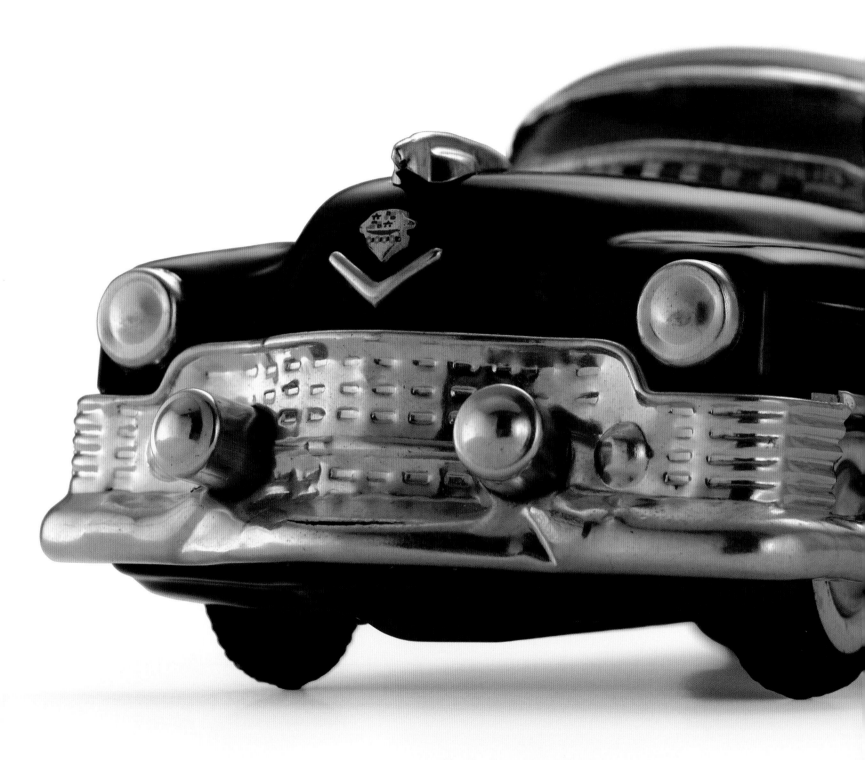

6
General Motors Cadillac 62
Four-Door Sedan, 1950;
with friction motor.
9 ½ x 3 ⅞ x 3 ⅛ in. (24 x 10 x 8 cm).
Suzuki Gangu, about 1953–54.

The little-known Suzuki company was
one of several manufacturers that put
out toy Cadillacs to compete with
Marusan's remarkably realistic and highly
finished versions.

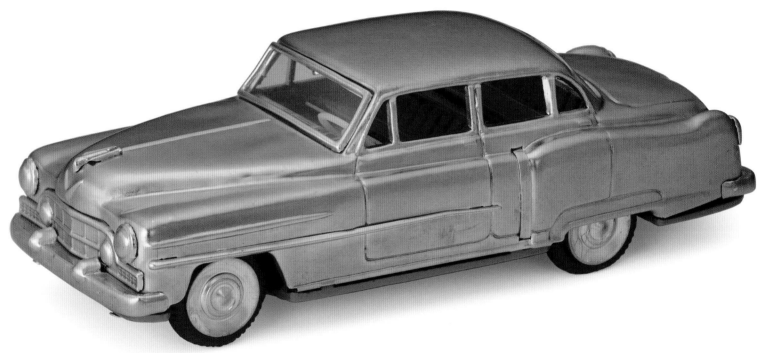

7

General Motors Cadillac 62
Four-Door Sedan, 1950;
with friction motor.
7 ½ x 6 ¾ x 2 ⅛ in. (19 x 17 x 5.5 cm).
Shioji Shōten (SSS), about 1953–56.

This gold version is said to have been put on the market after
the opening of a 1953 Broadway show, "The Solid Gold
Cadillac." Since the film version of the show was not released
until 1956, the gold color only yields an approximate date.

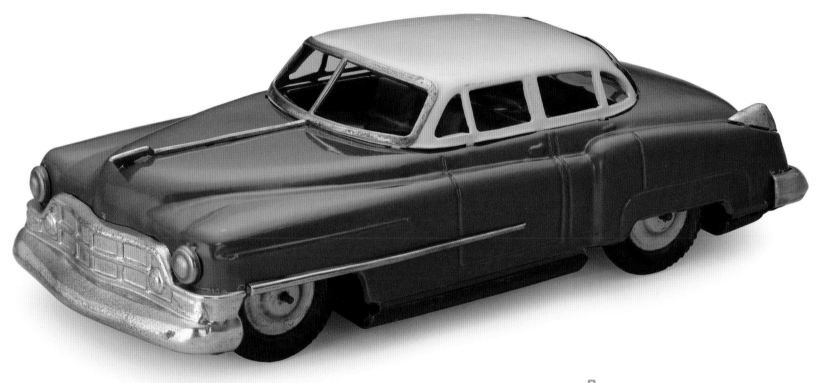

8
General Motors Cadillac 62
Four-Door Sedan, 1950;
with friction motor.
13¾ x 6¼ x 4⅜ in. (35 x 16 x 11 cm).
1953–54.

Nothing is known about the manufacturer
of this larger emulation of the celebrated
Marusan Cadillac toy car.

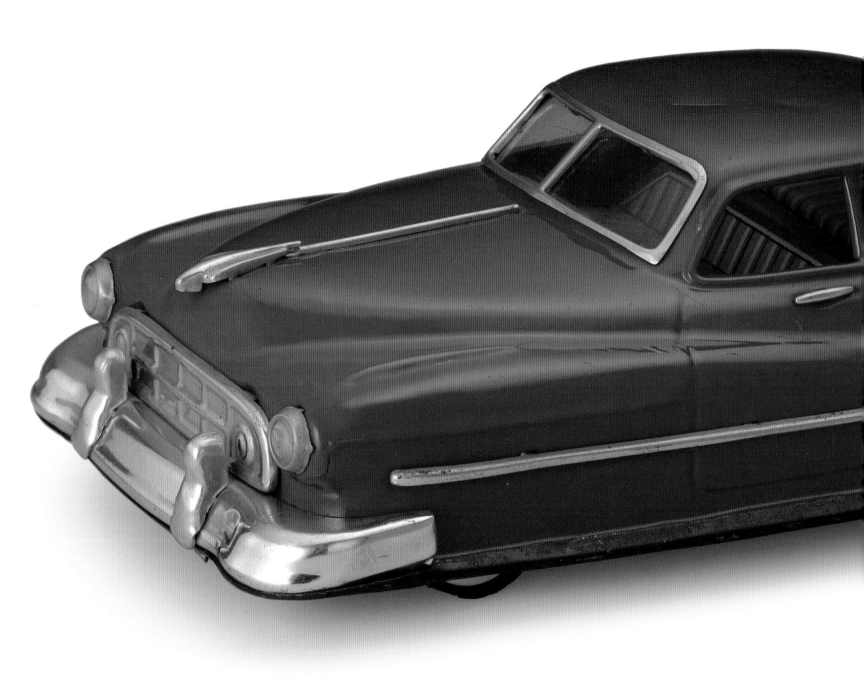

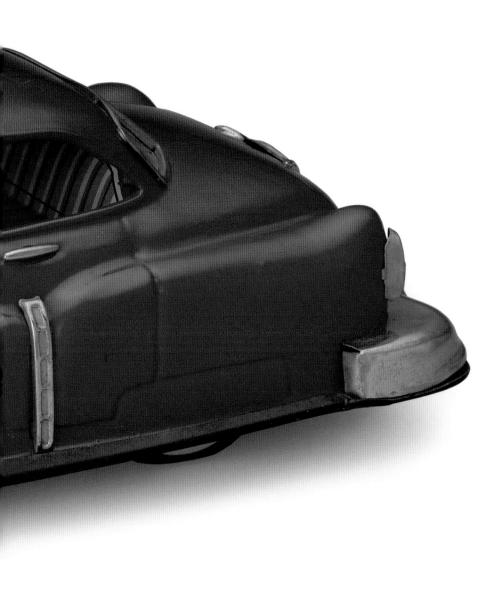

9
General Motors Cadillac 61
Four-Door Sedan, 1950;
with friction motor.
11 x 5½ x 3½ in. (28 x 14 x 9 cm).

This less-sophisticated model is identified
as a Cadillac 61 rather than a Cadillac 62
from the lack of an additional window behind
the rear doors. An American advertisement
for a similar real car sums up the appeal of
the Cadillac brand in the early 1950s: " . . .
the roster of Cadillac owners comprises a
virtual listing of the best known and most
respected names of our day . . . men and
women of recognized achievement and
accomplishment . . . leaders in virtually every
phase of business, of industry and of the
professions . . . They demand great beauty,
great performance and great distinction."

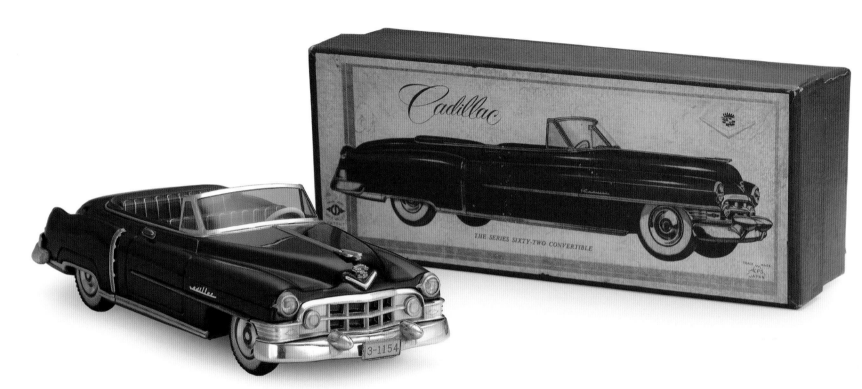

10

General Motors Cadillac 62 Eldorado Two-Door
Convertible, 1950;
with friction motor.
11 ³/₈ x 4 ³/₄ x 3 ⅛ in. (29 x 12 x 8 cm). Alps Shōji.

According to an unverifiable online source, after General Motors
pointed out to the Alps company that they had no license to produce
Cadillac models, the name on the badges was changed to "Wadillac."
The same source states that Alps produced this sought-after toy for
only three years.

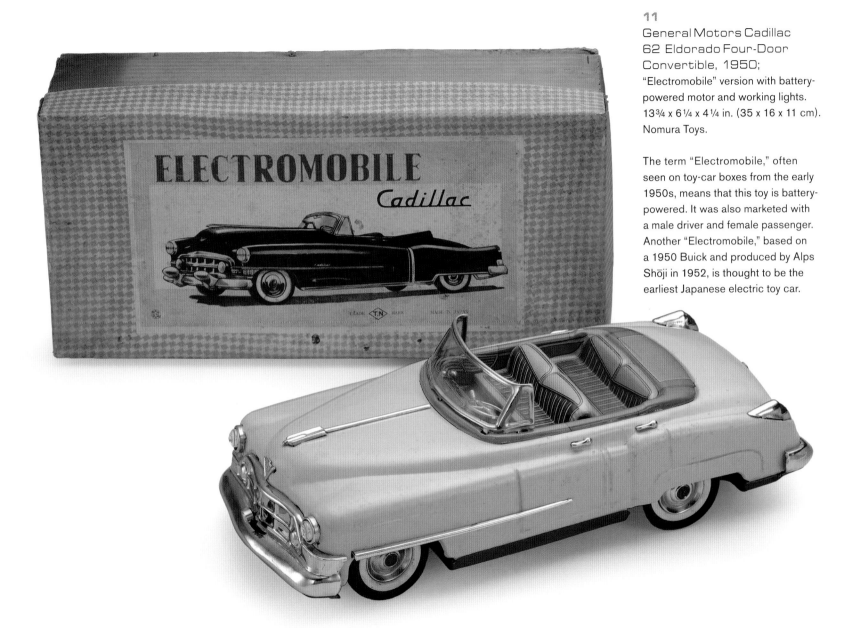

11

General Motors Cadillac
62 Eldorado Four-Door
Convertible, 1950;
"Electromobile" version with battery-
powered motor and working lights.
13¾ x 6¼ x 4¼ in. (35 x 16 x 11 cm).
Nomura Toys.

The term "Electromobile," often
seen on toy-car boxes from the early
1950s, means that this toy is battery-
powered. It was also marketed with
a male driver and female passenger.
Another "Electromobile," based on
a 1950 Buick and produced by Alps
Shōji in 1952, is thought to be the
earliest Japanese electric toy car.

ELECTROMOBILE
Cadillac

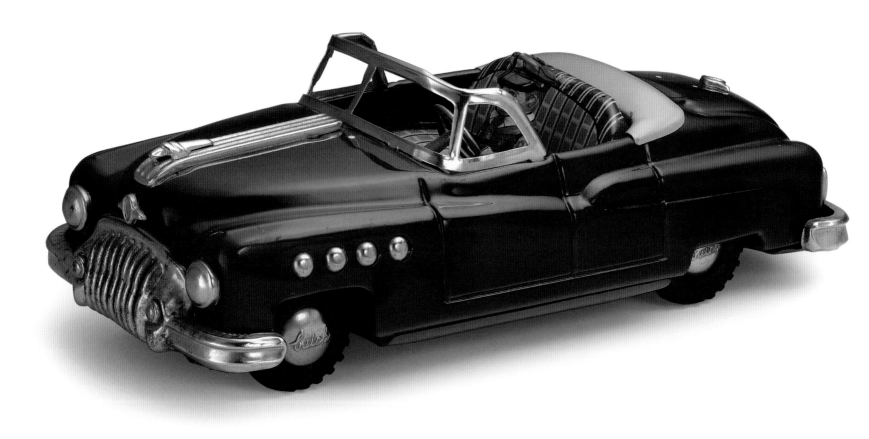

12
General Motors Buick
Four-Door Convertible, 1950.
10¾ x 4¾ x 4¼ in. (27.5 x 12 x 11 cm).

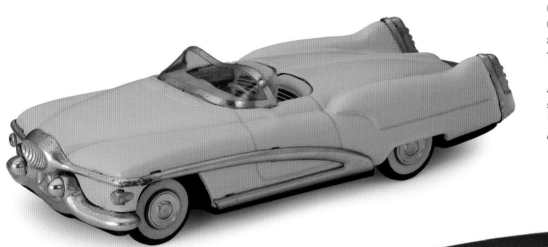

13

General Motors Buick Two-Door
Convertible, 1950s.
8 ⅛ x 3 ¼ x 2 in. (20.5 x 8 x 5 cm).
Yonezawa Gangu.

Although the bold chrome decoration on the
sides identifies this simple toy as an early
1950s Buick, the styling of the tailfins seems
closer to a Cadillac of the same date.

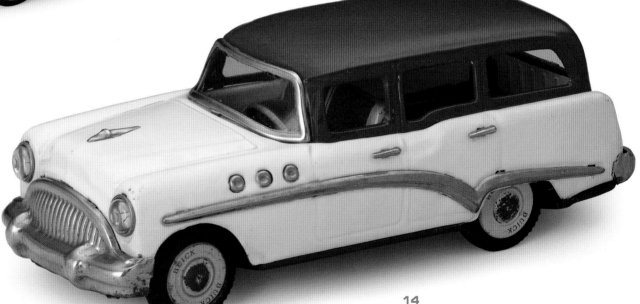

14

General Motors Buick
Four-Door Estate Wagon, 1952.
8 ¼ x 3 ½ x 3 ⅛ in. (21 x 9 x 8 cm).

15

Chrysler Windsor Deluxe
Two-Door Convertible, 1952.
9 7/8 x 4 3/8 x 3 1/2 in. (25 x 11 x 9 cm).
Manufactured for Hadson Trading Co. Ltd.

Hadson, like Cragstan (see cat. 34), was a
U.S. importer of Japanese toys.

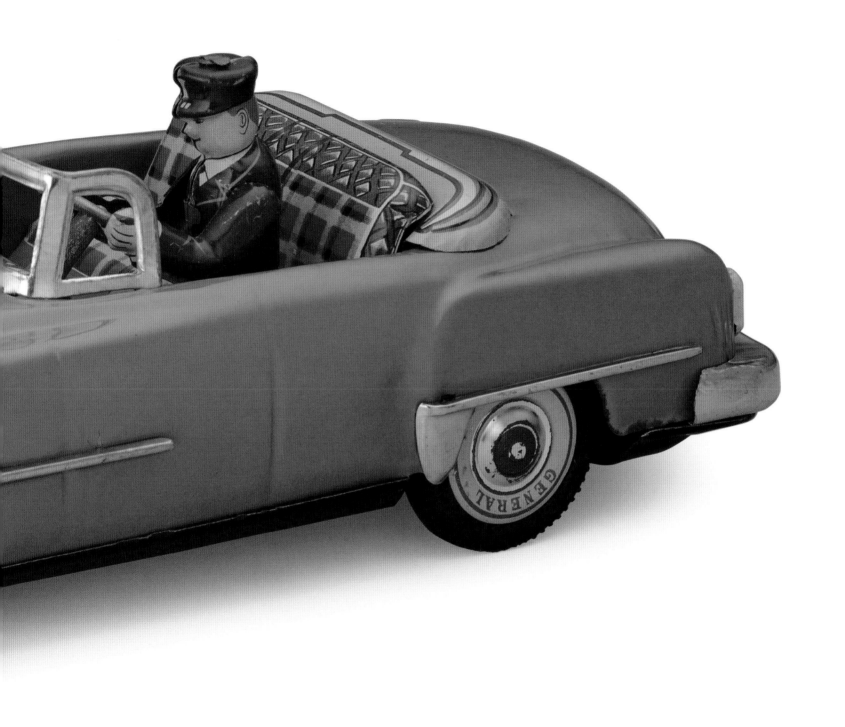

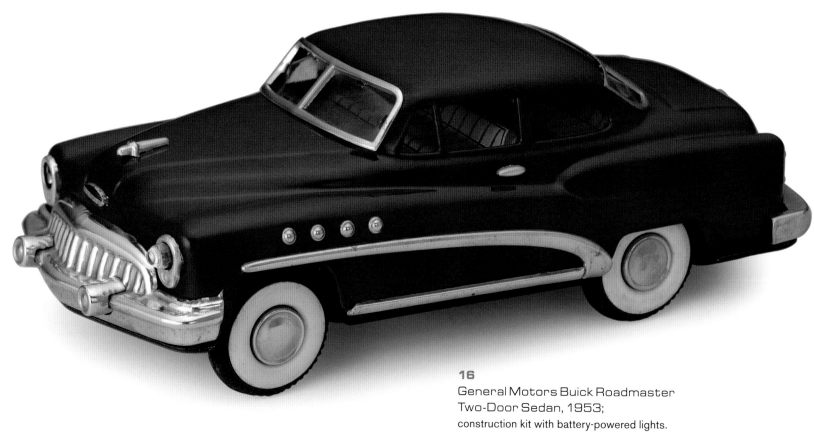

16

General Motors Buick Roadmaster
Two-Door Sedan, 1953;
construction kit with battery-powered lights.
7 ½ x 7 ⅛ x 2 ½ in. (19 x 18 x 6.5 cm).
Marusan Shōten, about 1954.

The promotional text on the box (see p. 15) reads, "Sister car of our
famous "Cadillac" favoured by our young friends. Smaller, but now
appeared with LIGHTS. A toy, but more than a toy. Another hit item for
this year produced by MARUSAN." This model was also marketed in
Japan with promotional copy that emphasized its success in foreign
department stores.

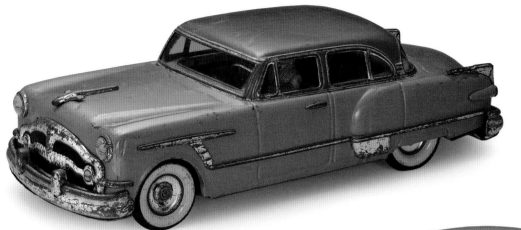

17
Packard Patrician 400
Four-Door Sedan, 1953.
16½ x 6¾ x 4¾ in. (42 x 17.5 x 12 cm).
Alps Shōji.

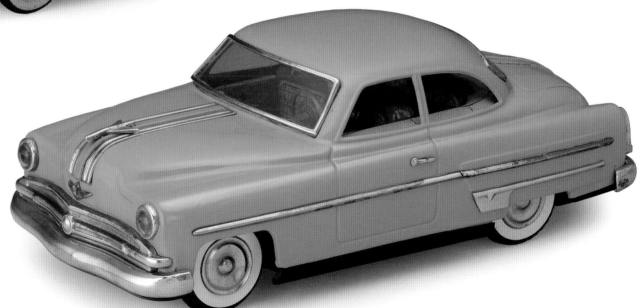

18
General Motors Pontiac
Two-Door Sedan, 1953.
15 x 7⅛ x 5⅛ in. (38 x 18 x 13 cm).

19

Studebaker-Packard Studebaker
Champion Two-Door Coupe, 1954.
6 ¾ x 3 x 2 ⅛ in. (17 x 7.5 x 5.5 cm).
Marusan Shōten.

Studebakers of this period were marketed in
the United States as "The new American car
with the European look."

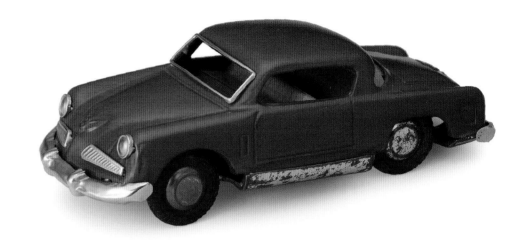

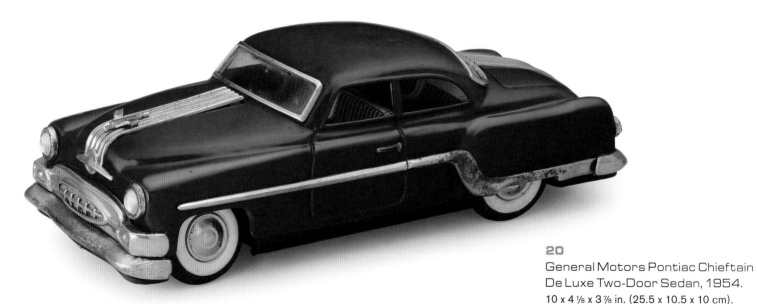

20

General Motors Pontiac Chieftain
De Luxe Two-Door Sedan, 1954.
10 x 4 ⅛ x 3 ⅞ in. (25.5 x 10.5 x 10 cm).
Asahi Gangu.

This car was also modeled by Amartoy,
an Indian company.

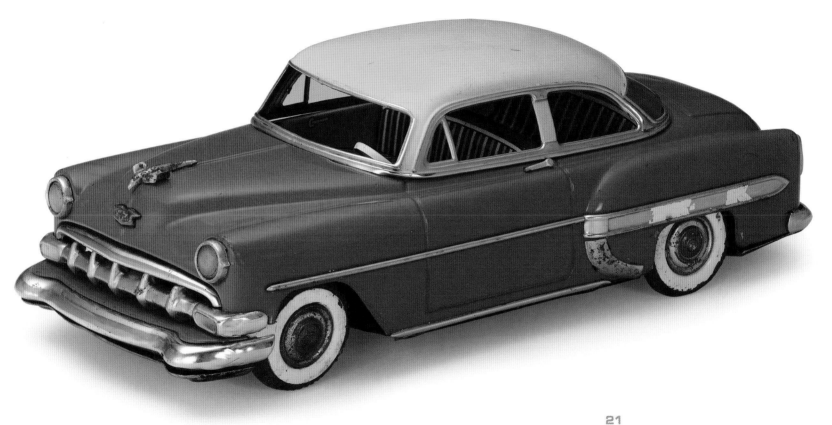

21
General Motors Chevrolet Bel Air
Two-Door Sedan, 1954.
11 ⅜ x 5 ⅛ x 3 ¾ in. (29 x 13 x 9.5 cm).
Marusan Shōten.

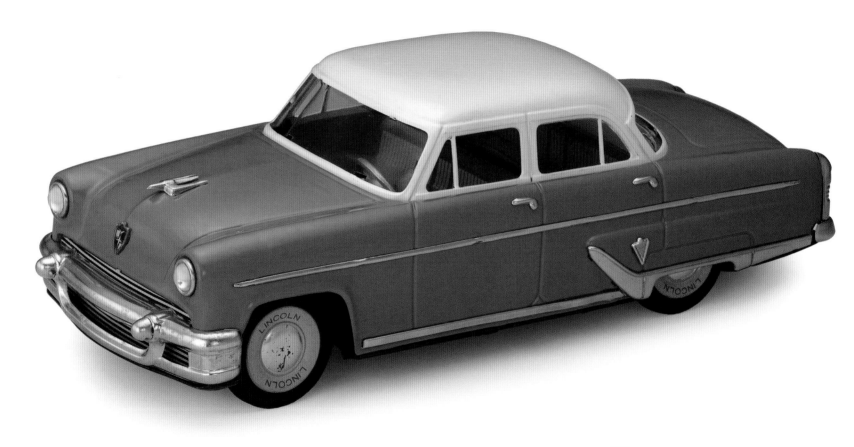

22
Ford Lincoln Capri
Four-Door Sedan, 1955.
12 ⅝ x 4 ¾ x 4 ⅜ in. (32 x 12 x 11 cm).
Yonezawa Gangu.

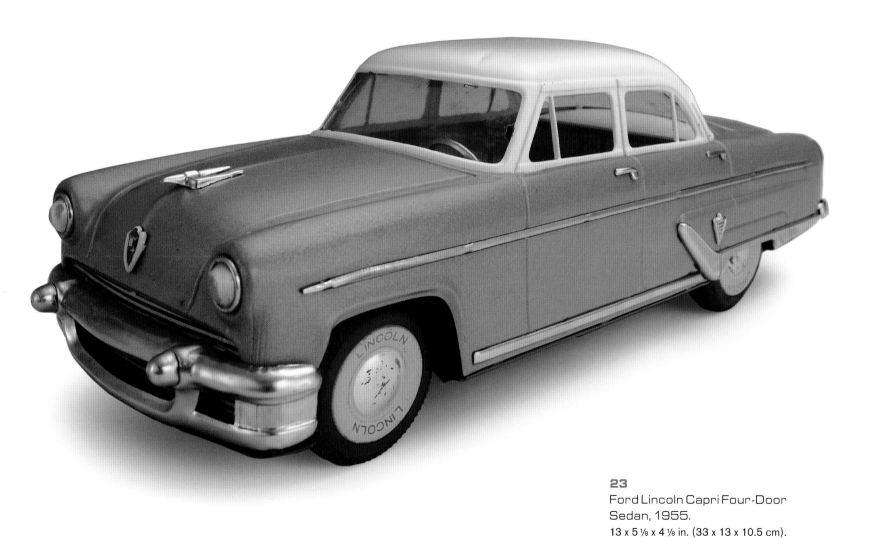

23
Ford Lincoln Capri Four-Door
Sedan, 1955.
13 x 5 ⅛ x 4 ⅛ in. (33 x 13 x 10.5 cm).
Yamazaki.

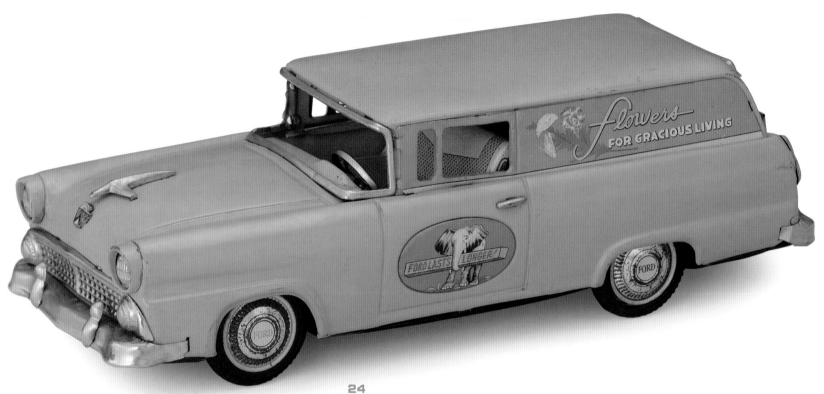

24

Ford Two-Door Sedan Delivery Vehicle, 1956;
with friction motor.
12 ¼ x 4 ½ x 3 ⅞ in. (31 x 11.5 x 10 cm).
Bandai.

This is an early example of a car made by the Bandai company, founded in 1950. Unlike many of the other specialist companies that built successful toy-car businesses in the 1950s but closed down in the following decade due to changing consumer preferences, Bandai has constantly updated its product range and moved into new areas to become the global brand it is today. The piece of timber carried by the elephant on the door is inscribed, "Ford Lasts Longer." Another documented version of this vehicle is inscribed on the side with "Standard Fresh Coffee," and on the door with "Rain or Shine, I'm On Time."

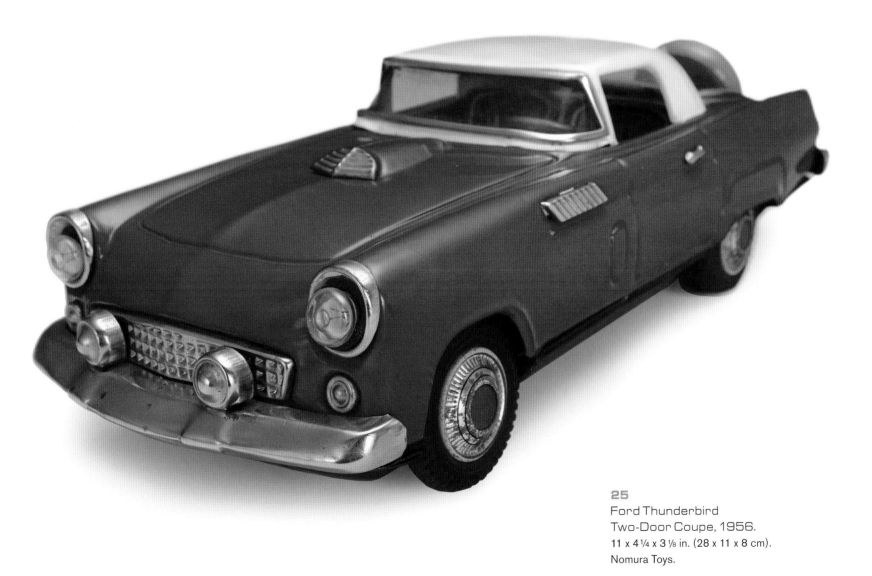

25
Ford Thunderbird
Two-Door Coupe, 1956.
11 x 4 ¼ x 3 ⅛ in. (28 x 11 x 8 cm).
Nomura Toys.

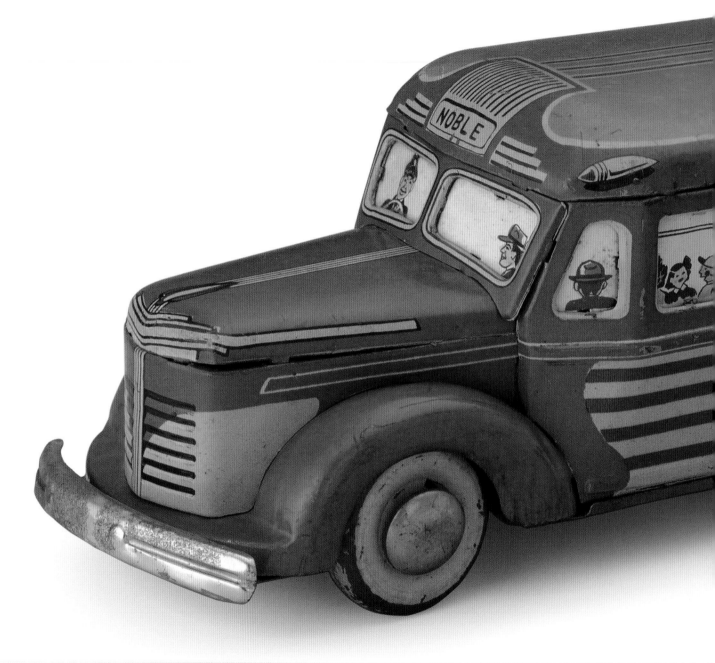

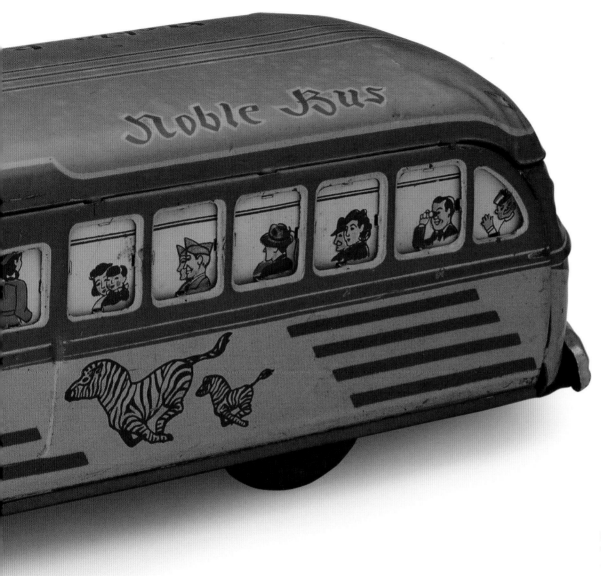

26
"Noble Bus," mid-1950s.
12 x 3⅜ x 3¾ in. (30.5 x 8.5 x 9.5 cm).
Kaname Sangyō.

Lithographed passengers similar to those
seen here appear on a model of a 1953
Ford station wagon, suggesting that this
bus was probably made in the mid-1950s.

27

Greyhound Bus, mid-1950s.
12⅝ x 3½ x 3½ in. (32 x 9 x 9 cm).

The simple manufacture of this bus, with
driver and passengers lithographed onto
metal plates partly cut from the chassis
and bent up at a 90-degree angle, puts it
into a different category from the luxurious
Cadillac and other models that were being
made around the same time. The license
plate reads, "NEW YORK."

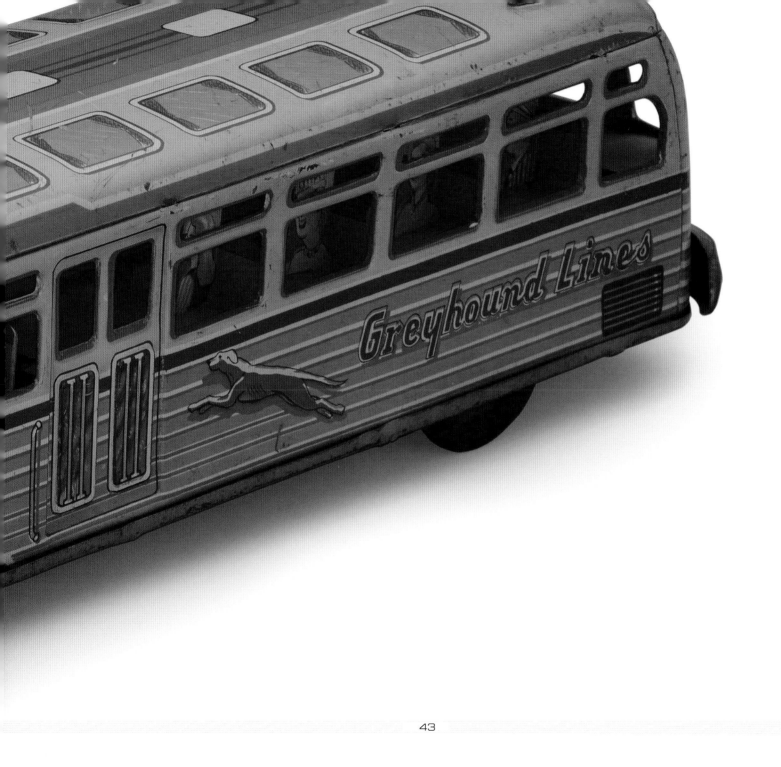

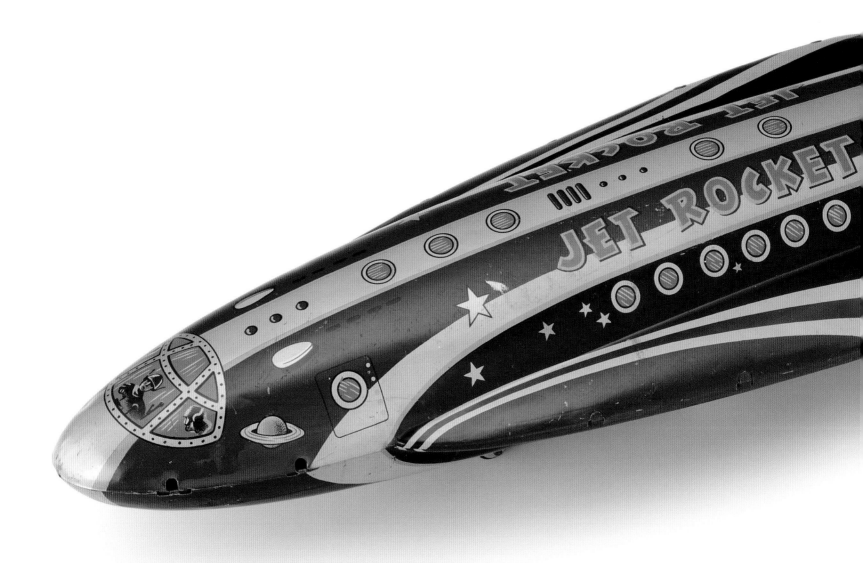

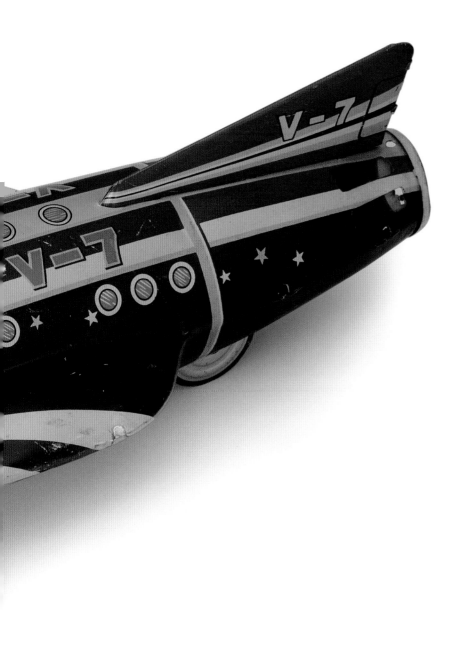

28
"Jet Rocket," early 1950s;
with friction motor.
18 ⅞ x 6 ¼ x 4 ¾ in. (48 x 16 x 12 cm).

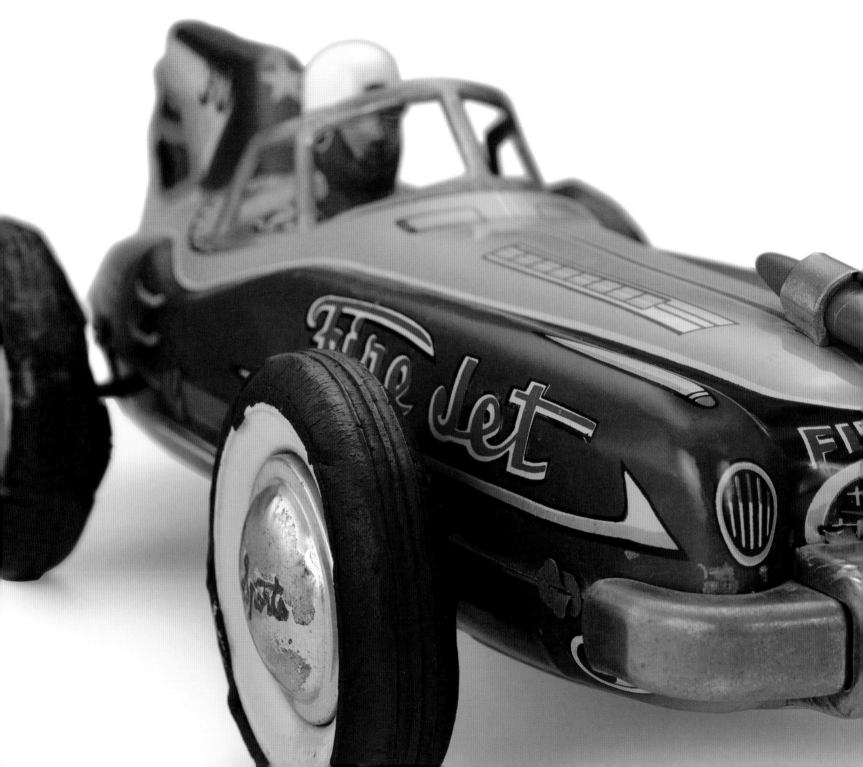

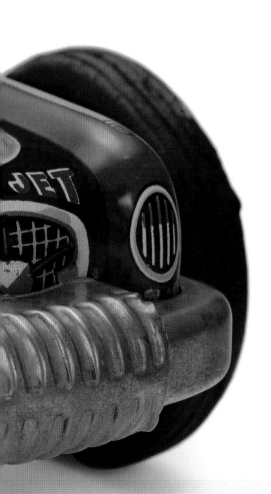

29
"Fire Jet" racing car, about 1955.
13 3/8 x 6 1/4 x 5 1/8 in. (34 x 16 x 13 cm).
Asahi Gangu.

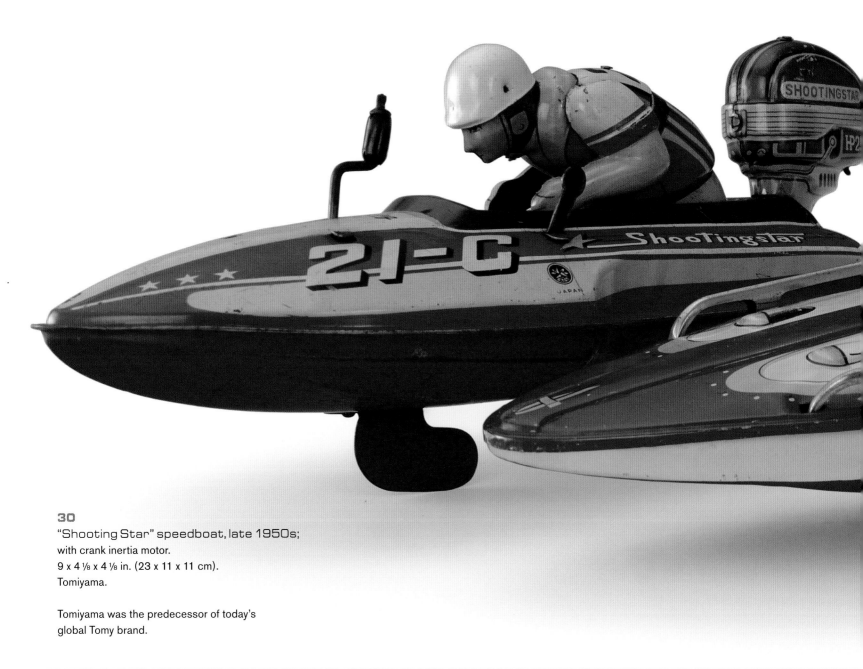

30

"Shooting Star" speedboat, late 1950s;
with crank inertia motor.
9 x 4 ⅛ x 4 ⅛ in. (23 x 11 x 11 cm).
Tomiyama.

Tomiyama was the predecessor of today's
global Tomy brand.

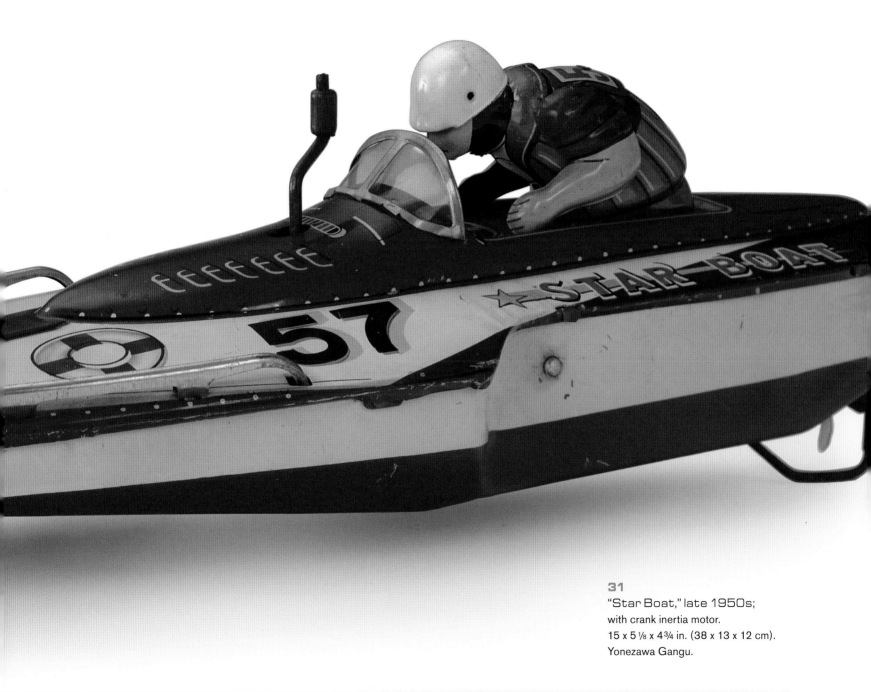

31
"Star Boat," late 1950s;
with crank inertia motor.
15 x 5 ⅛ x 4¾ in. (38 x 13 x 12 cm).
Yonezawa Gangu.

32

"Super Jet," late 1950s.

12 ⅝ x 6 ¼ x 5 ⅛ in. (32 x 16 x 13 cm).

Nomura Toys.

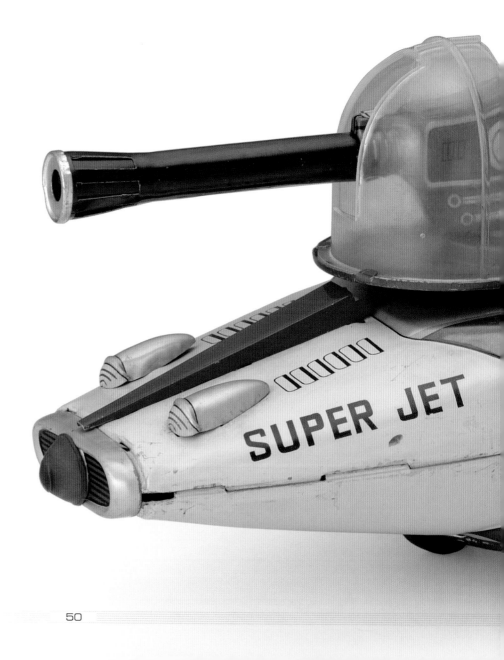

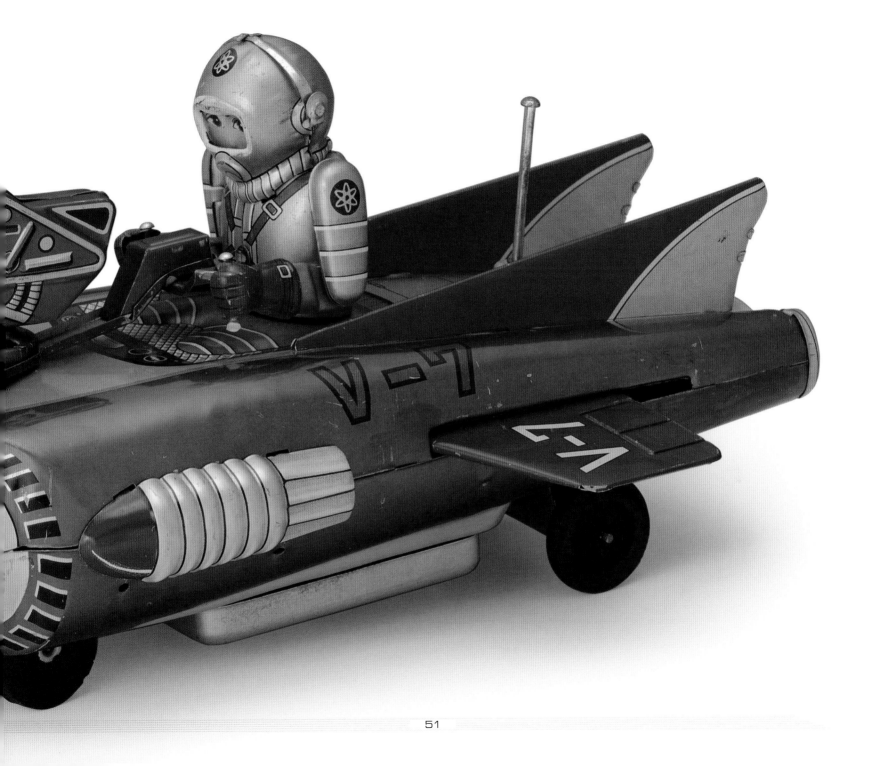

33

Ford Fairlane, about 1955;
with trailer.
5 ½ x 2 ⅜ x 1 ¾ in. (14 x 6 x 4.5 cm),
6 ¾ x 3 ⅛ x 3 ⅜ in. (17 x 8 x 8.5 cm).
Shioji Shōten (SSS) for Cragstan
Corporation, New York.

This is a good example of the less pain-
stakingly modeled toy cars that were produced
for the lower end of the export market.
Although the distinctive chrome styling makes
it easy to identify the original make, the "Ford"
and "Fairlane" names are not mentioned on
the packaging, and many details are omitted.
Based in Osaka, Shioji Shōten Ltd. (also
known as San'esu, "Three 'S's") appears to
have specialized in toys with trailers or other
additional components.

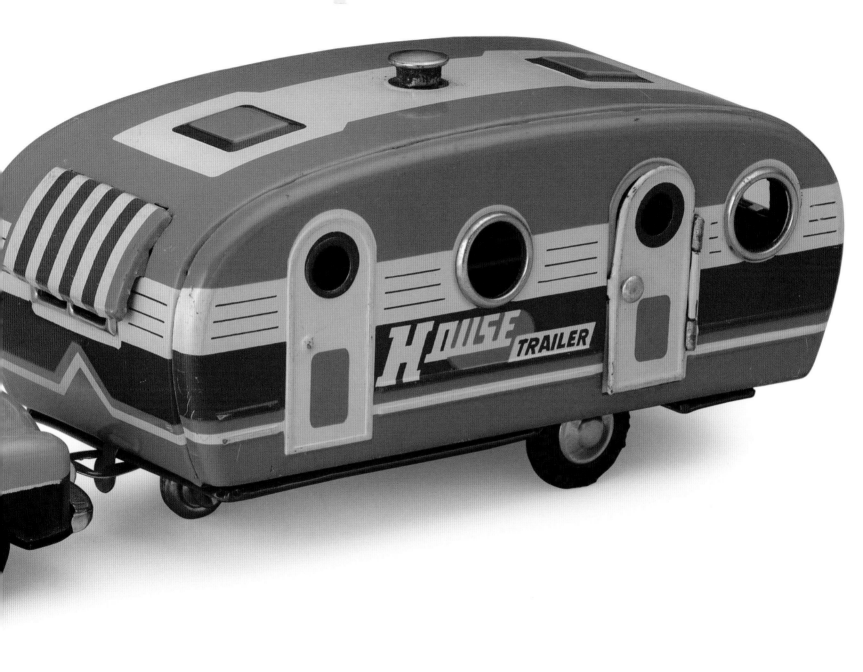

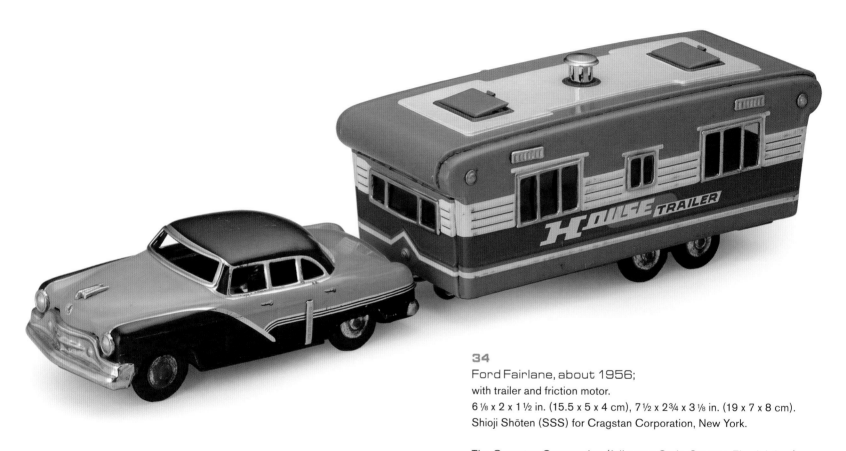

34

Ford Fairlane, about 1956;
with trailer and friction motor.
6 ⅛ x 2 x 1 ½ in. (15.5 x 5 x 4 cm), 7 ½ x 2¾ x 3 ⅛ in. (19 x 7 x 8 cm).
Shioji Shōten (SSS) for Cragstan Corporation, New York.

The Cragstan Corporation (full name Craig-Stanton-Elmaleh Inc.)
of 136 Fifth Avenue, New York, originally imported real automobiles
but entered the Japanese toy market in the mid-1950s. With its own
export office in Tokyo (Nippon Goraku Shōkai), Cragstan's aggressive
business practices, large orders, and demands for exclusive distribution
had a strong influence on the development of the Japanese toy industry.
The company is believed to have ceased trading in the 1960s.

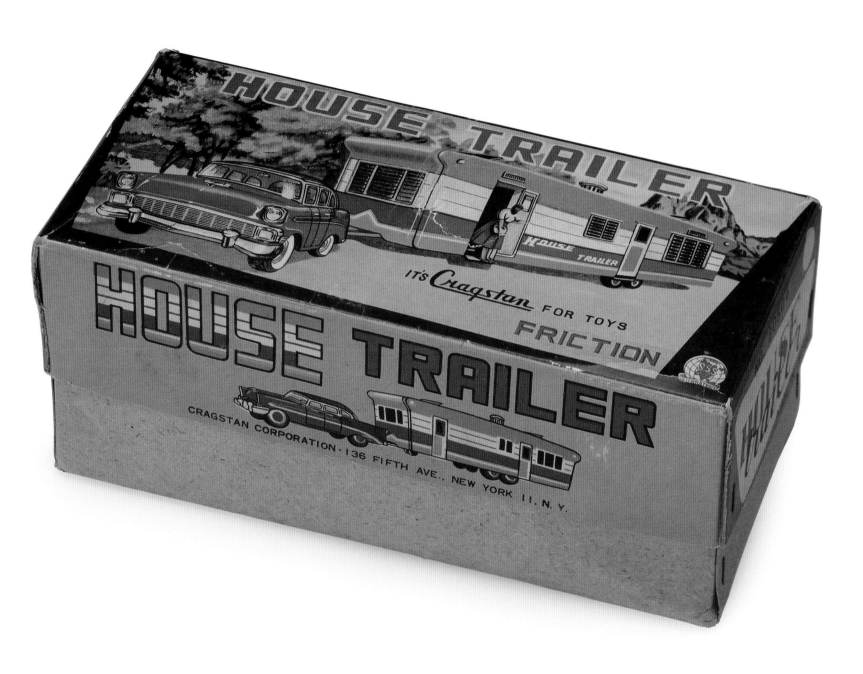

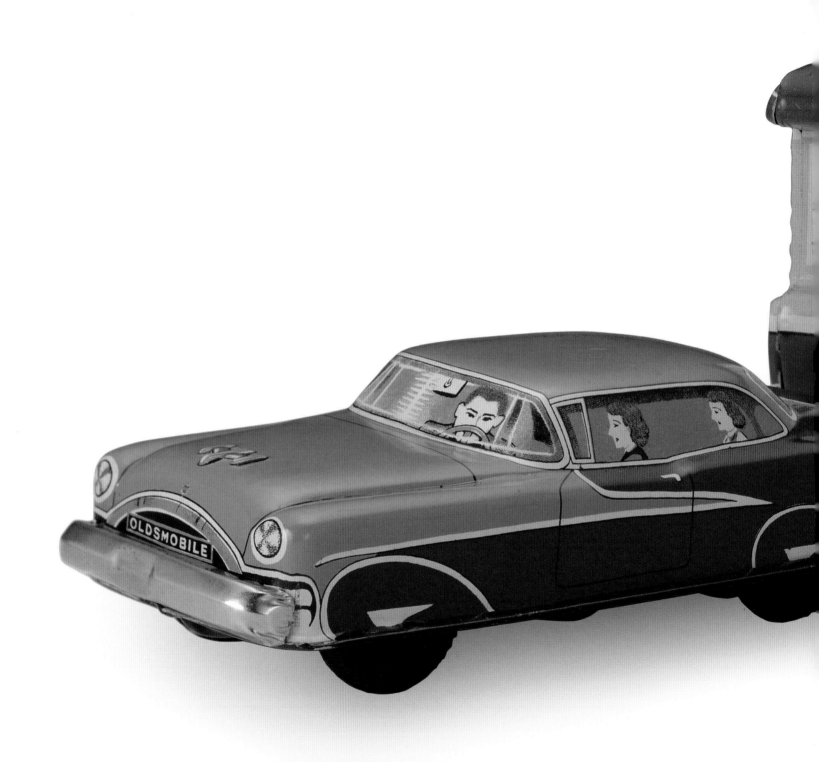

35
General Motors Oldsmobile
Two-Door Sedan, 1955;
with trailer.
5 ½ x 2 ⅜ x 1 ¾ in. (14 x 6 x 4.5 cm),
6 ¾ x 3 ⅛ x 3 ⅜ in. (17 x 8 x 8.5 cm).
Yonezawa Gangu.

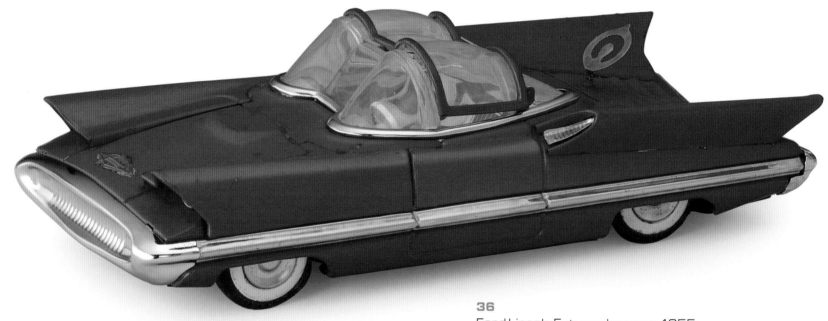

36

Ford Lincoln Futura show car, 1955;
with battery-powered lights.
11 x 5 ⅛ x 3 ¼ in. (28 x 13 x 8.5 cm).
Alps Shōji.

During the 1950s, leading automakers developed "concept" or "show" cars for display at trade fairs, and a few of them—like the Futura—had a complete power train and could actually be driven. Some features of the Futura influenced the styling of ordinary Lincoln cars in 1956 and 1957, but this show car finally achieved immortality in 1966 when it was used as the model for the Batmobile in the "Batman" television series.

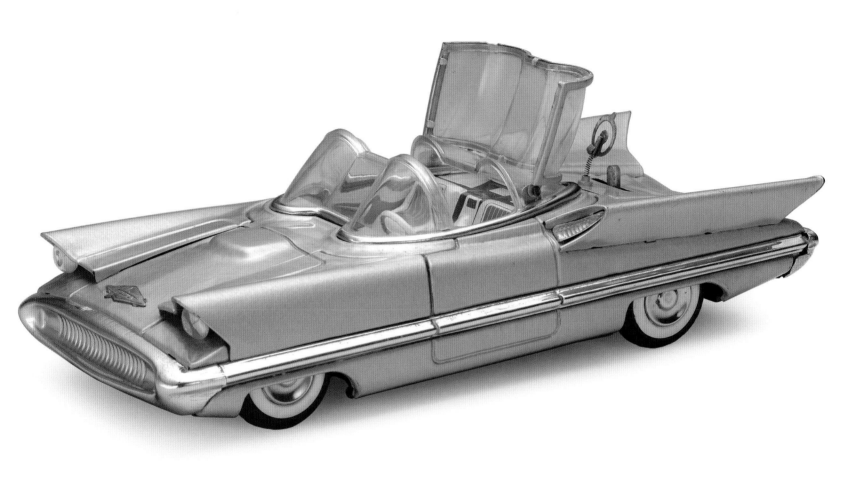

37
Ford Lincoln Futura show car, 1955;
with battery-powered lights.
11 x 7¾ x 3¼ in. (28 x 12 x 8.5 cm).
Alps Shōji.

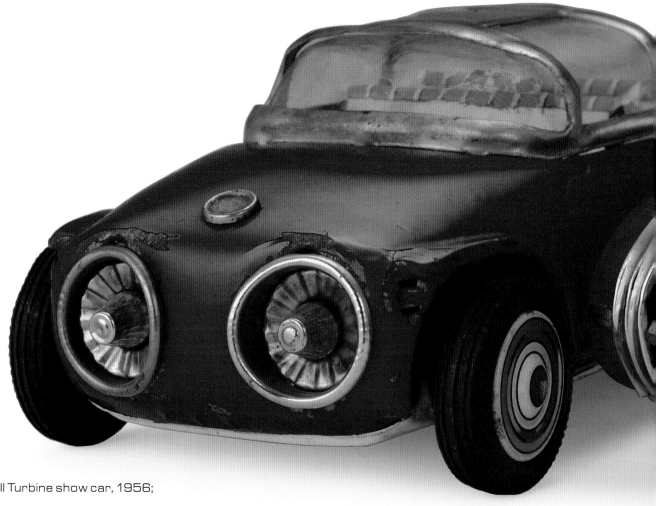

38

General Motors Firebird II Turbine show car, 1956;
with friction motor.
8 ⅝ x 3 ½ x 2 ¾ in. (22 x 9 x 7 cm).
Asahi Gangu for Cragstan Corporation, New York.

The brainchild of Harley Earl, head of General Motors Styling, the Firebird Turbine car was
intended to capture the feel and technology of a jet fighter. First constructed in fall of 1953,
the Firebird was further developed for the next two years and presented to the public at the 1956
General Motors Motorama, along with the Pontiac Club de Mer. It never went into production.

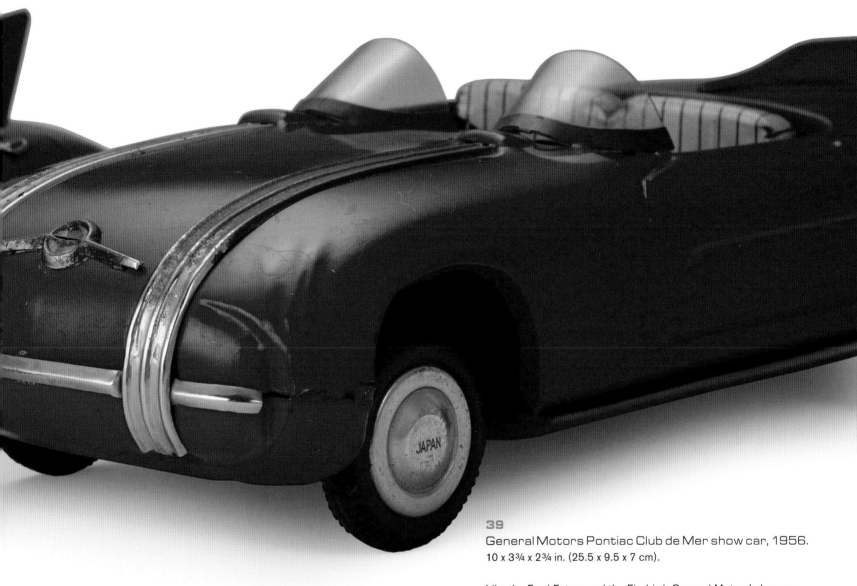

39

General Motors Pontiac Club de Mer show car, 1956.
10 x 3¾ x 2¾ in. (25.5 x 9.5 x 7 cm).

Like the Ford Futura and the Firebird, General Motors' show car,
unveiled at the 1956 Motorama show, was inspired by contemporary
aircraft construction. Only one prototype was manufactured before
the model was scrapped in 1958.

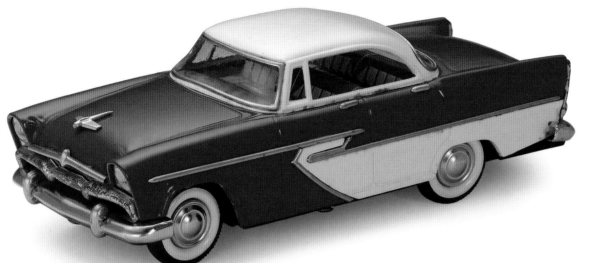

40

Plymouth Belvedere Four-Door
Hardtop, 1956;
with bumper-activated reversing action.
11 ⅞ x 7¾ x 3¾ in. (30 x 12 x 9.5 cm).
Alps Shōji.

This car, which features "Mystery Car
Automatic Reversing" (see cat. 70),
came in a box decorated with famous
structures from around the world,
including the Statue of Liberty, the
Sphinx, the Leaning Tower of Pisa,
and London's Tower Bridge.

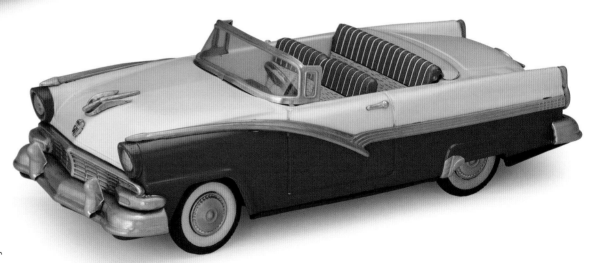

41

Ford Fairlane Victoria Sunliner
Two-Door Convertible, 1956.
11 ⅜ x 4¾ x 3½ in. (29 x 12 x 9 cm).
Haji Toys (Mansei Gangu).

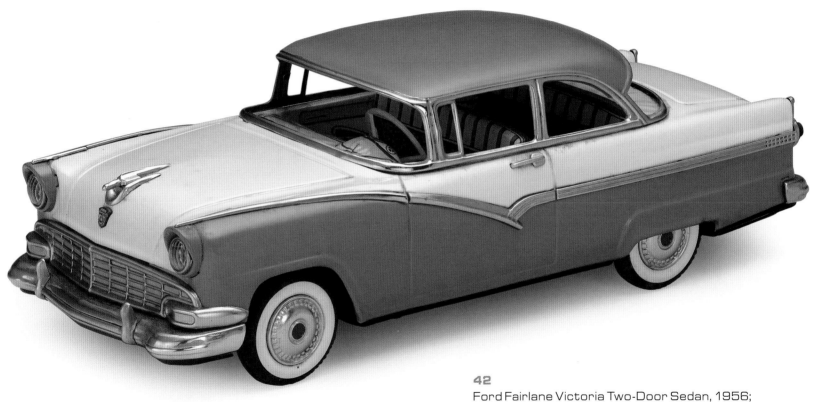

42
Ford Fairlane Victoria Two-Door Sedan, 1956;
with friction motor.
13 ⅛ x 5 ⅛ x 4 ¼ in. (33.5 x 13 x 11 cm).
Marusan Shōten.

This very accurately copied 1956 Ford by Marusan is among the most
highly prized of all Japanese toy cars.

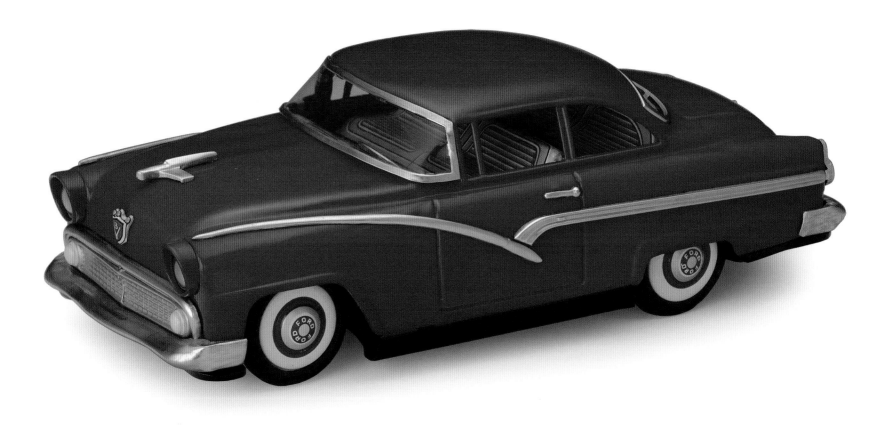

43
Ford Fairlane Victoria
Two-Door Sedan, 1956.
10¼ x 4⅛ x 3⅜ in. (26 x 10.5 x 8.5 cm).

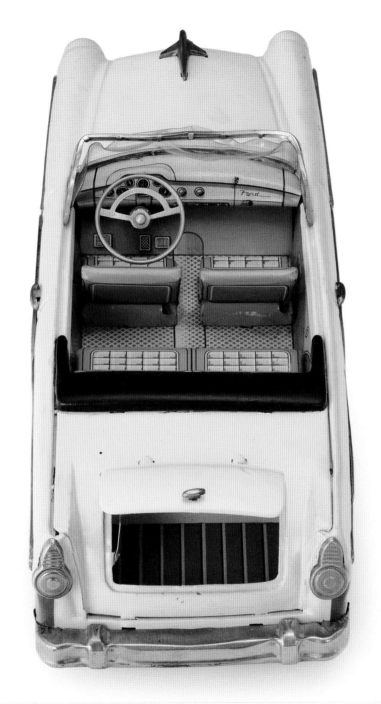

44
Ford Fairlane Two-Door
Convertible, 1956.
11 ⅞ x 4 ⅛ x 3 ⅛ in. (30 x 10.5 x 8 cm).
Bandai.

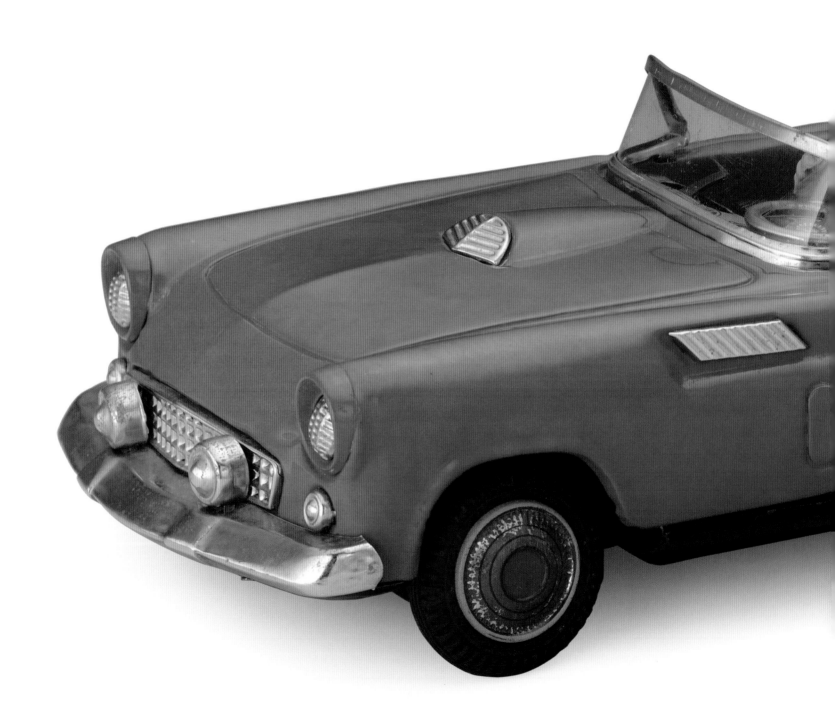

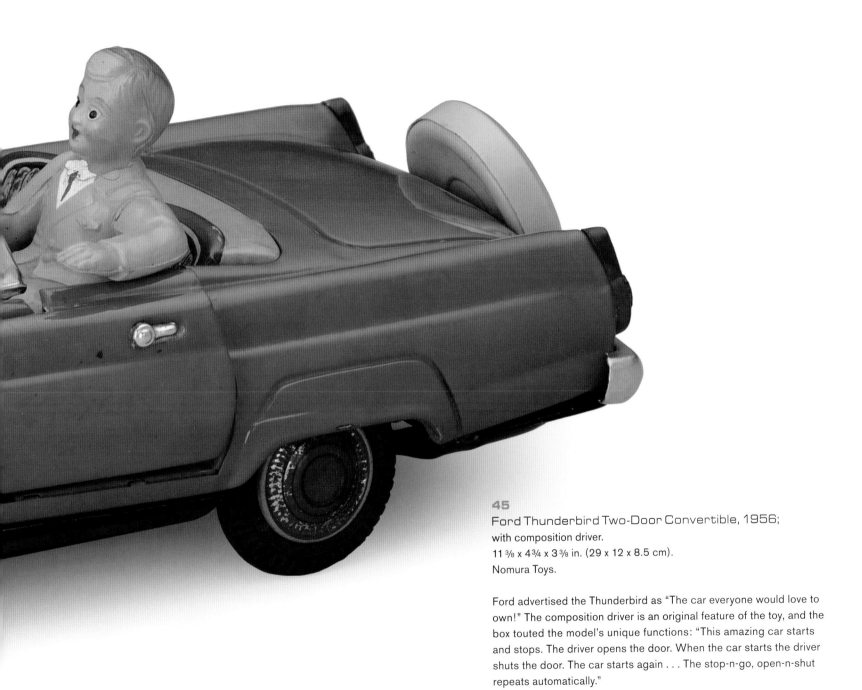

45

Ford Thunderbird Two-Door Convertible, 1956;
with composition driver.
11 ³⁄₈ x 4¾ x 3 ³⁄₈ in. (29 x 12 x 8.5 cm).
Nomura Toys.

Ford advertised the Thunderbird as "The car everyone would love to own!" The composition driver is an original feature of the toy, and the box touted the model's unique functions: "This amazing car starts and stops. The driver opens the door. When the car starts the driver shuts the door. The car starts again . . . The stop-n-go, open-n-shut repeats automatically."

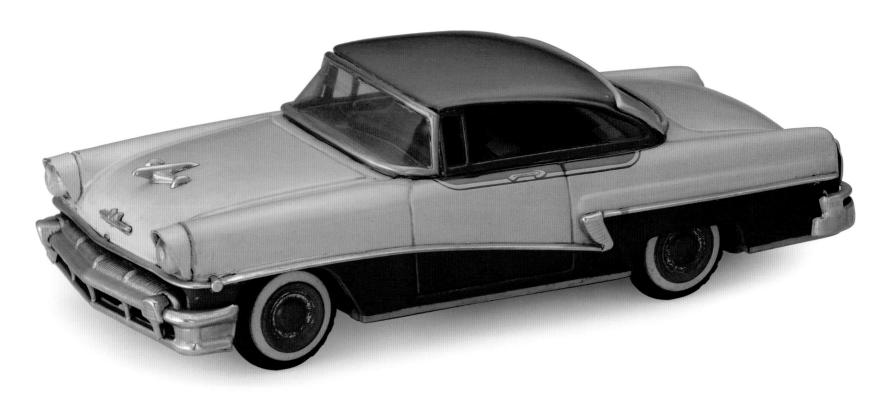

46
Ford Mercury Medalist
Two-Door Hardtop, 1956;
with forward/reverse function and headlights.
9 5/8 x 3 7/8 x 6 7/8 in. (24.5 x 10 x 17.5 cm).
Alps Shōji.

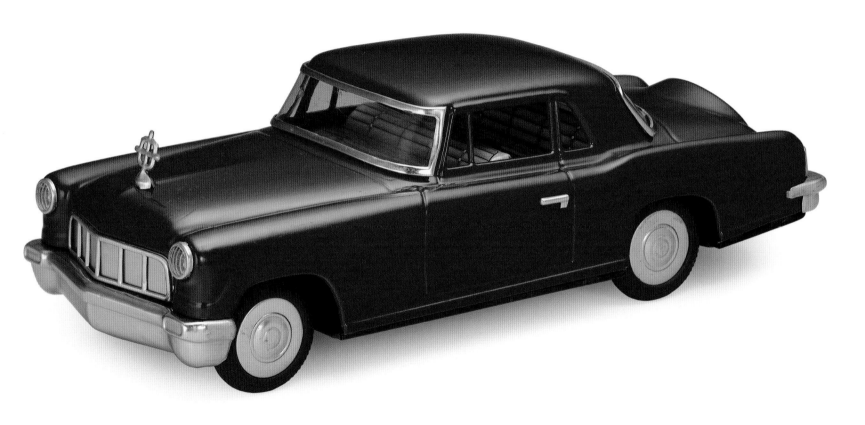

47
Ford Lincoln Continental Two-Door
Sedan, 1956.
13 x 4¾ x 4 in. (33 x 12 x 10 cm).
Marusan Shōten.

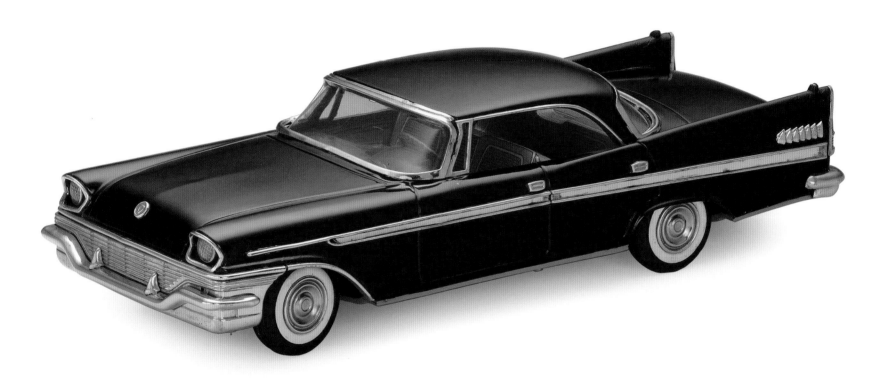

48
Chrysler New Yorker Four-Door
Sedan, 1957.
14 ⅛ x 5 ¼ x 3 ½ in. (36 x 13.5 x 9 cm).
Alps Shōji.

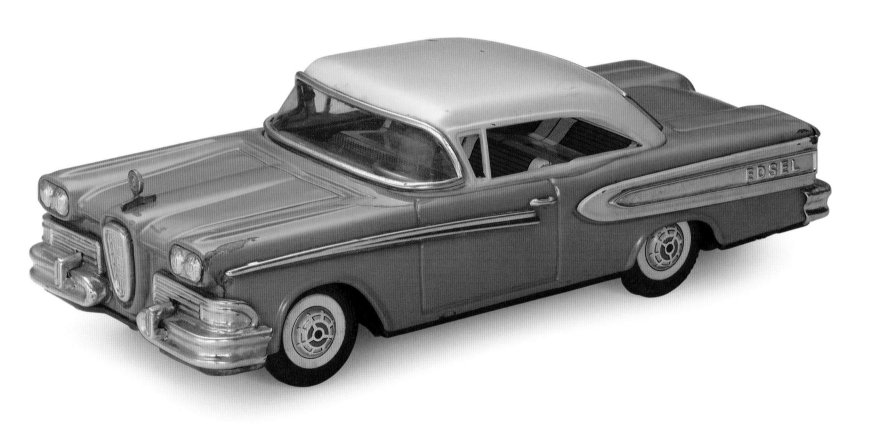

49
Ford Edsel Citation Two-Door
Hardtop, 1958.
10 ⅝ x 4 ¼ x 3 ⅛ in. (27 x 11 x 8 cm).
Yamazaki.

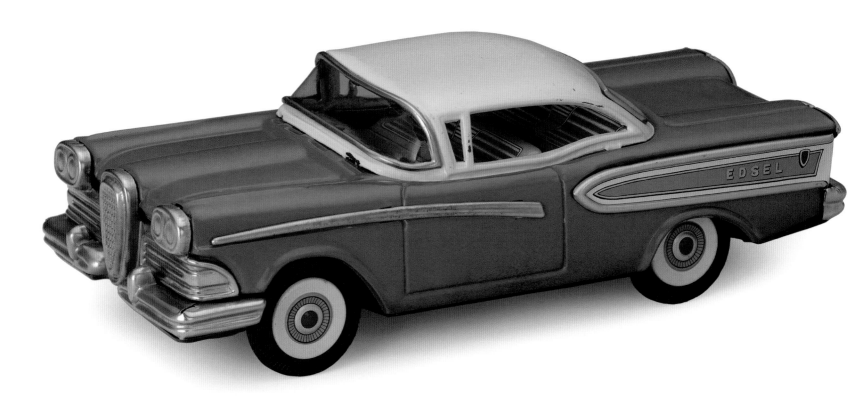

50
Ford Edsel Citation Two-Door
Hardtop, 1958;
with friction motor and working siren.
9 x 3⅞ x 3 in. (23 x 10 x 7.5 cm).
Nomura Toys.

51
Ford Edsel Citation Two-Door
Hardtop, 1958;
with friction motor.
10 ⅞ x 4 ⅜ x 3 ⅛ in. (27.5 x 11 x 8 cm).
Asahi Gangu.

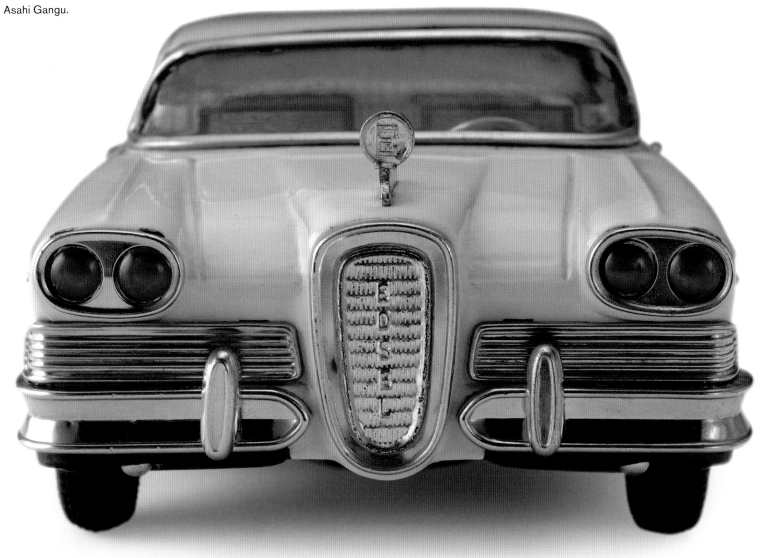

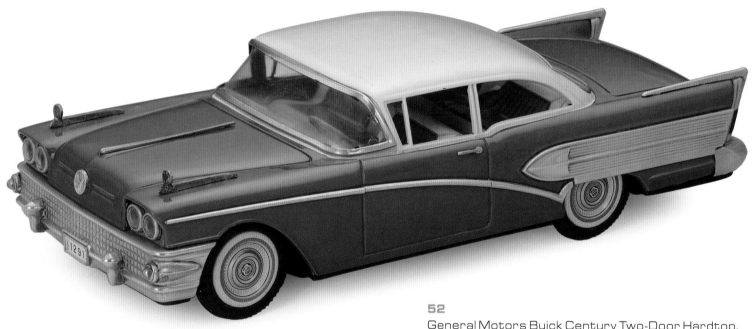

52

General Motors Buick Century Two-Door Hardtop, 1958;
with friction motor and working siren.
14 ⅛ x 6 ¼ x 3 ⅞ in. (36 x 16 x 10 cm).
Ichikō Kōgyō for Asahi Gangu.

Like several of the largest toy companies, Asahi Gangu had no factories of its own and subcontracted all of its production, but it is unusual to find the names of both the actual maker and the toy company on the box, as here. This model was marketed in a variety of two-tone and solid-color versions.

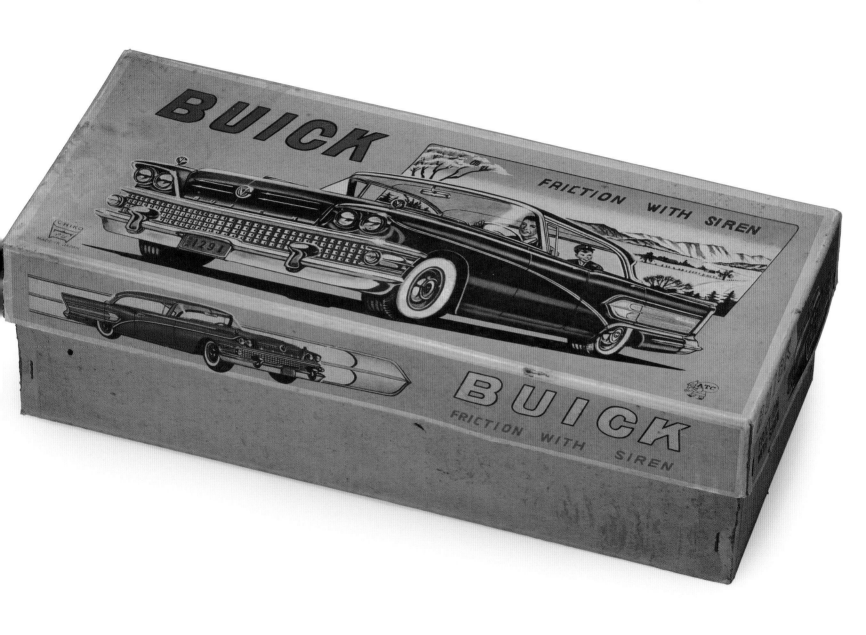

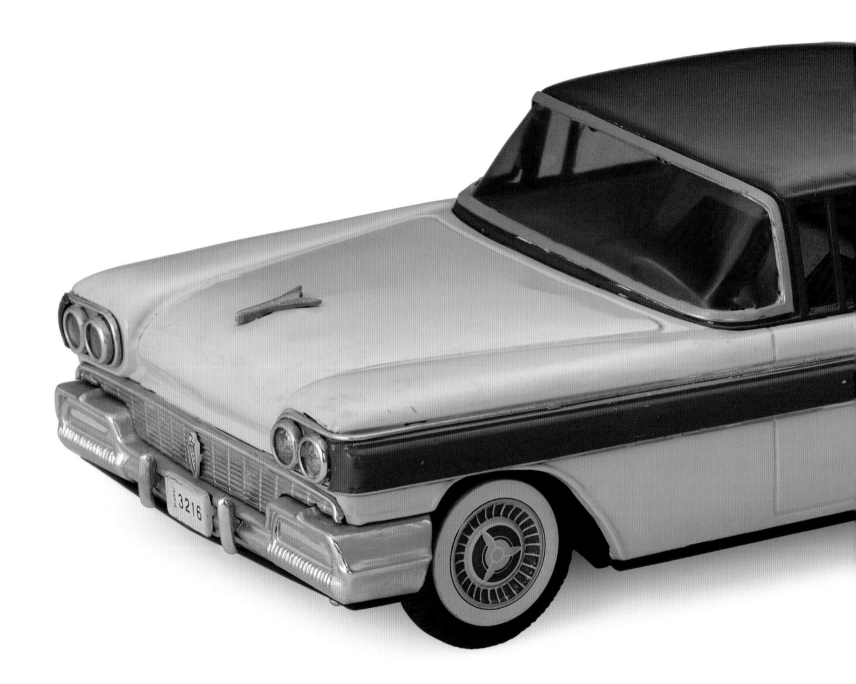

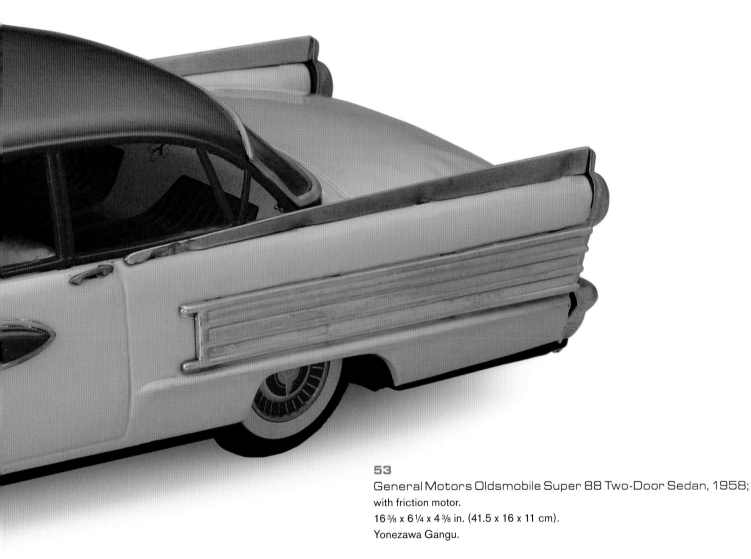

53

General Motors Oldsmobile Super 88 Two-Door Sedan, 1958;
with friction motor.
16 ⅜ x 6 ¼ x 4 ⅜ in. (41.5 x 16 x 11 cm).
Yonezawa Gangu.

Oldsmobile's 1958 advertisements boasted " . . . a magnificent performer in the famous
Rocket tradition, and *offering the greatest improvement in fuel economy* in Oldsmobile
history. Beneath the exciting distinction of line and color . . . beyond the renowned power
plant . . . are new expressions of Oldsmobile's style and engineering leadership." This toy
model was also issued with a tin driver.

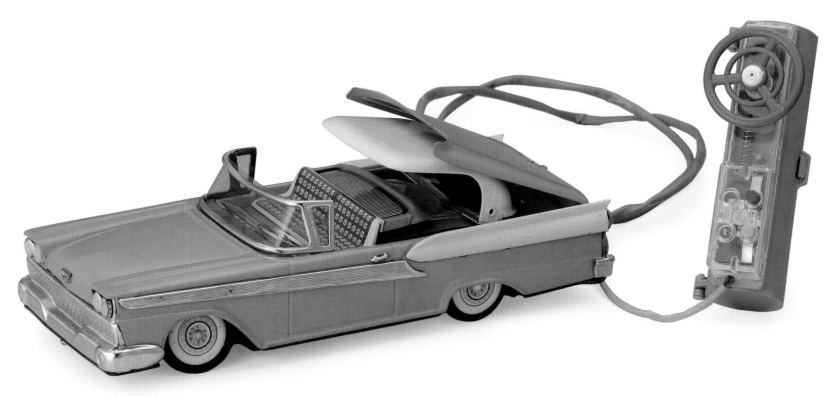

54

Ford Fairlane 500 Skyliner Two-Door Convertible
with retractable hardtop, 1959;
with battery-powered motor and remote control.
11 x 4½ x 2¾ in. (28 x 11.5 x 7 cm).
Manufactured for Cragstan Corporation, New York.

The box for this model promotes its "Amazing pushbutton automatic top-forward-reverse and steering." The instructions advise, "Switch at rear of car. Pull out for remote control of forward and reverse motion. Push in for remote control of automatic top. Keep remote control wire extended operating toy to prolong life of batteries. Take batteries out of container when toy is not in use."

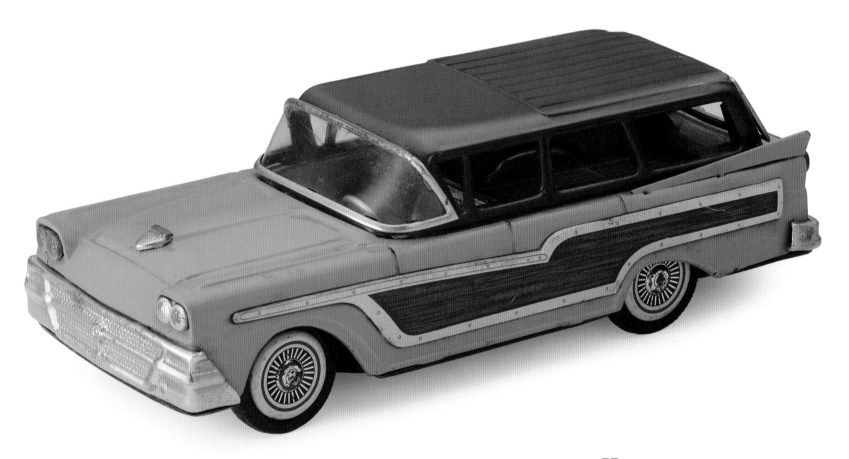

55
Ford Country Squire Four-Door
Ranch Wagon, 1959.
7 ⅞ x 3 ⅛ x 2 ⅜ in. (20 x 8 x 6 cm).
Bandai.

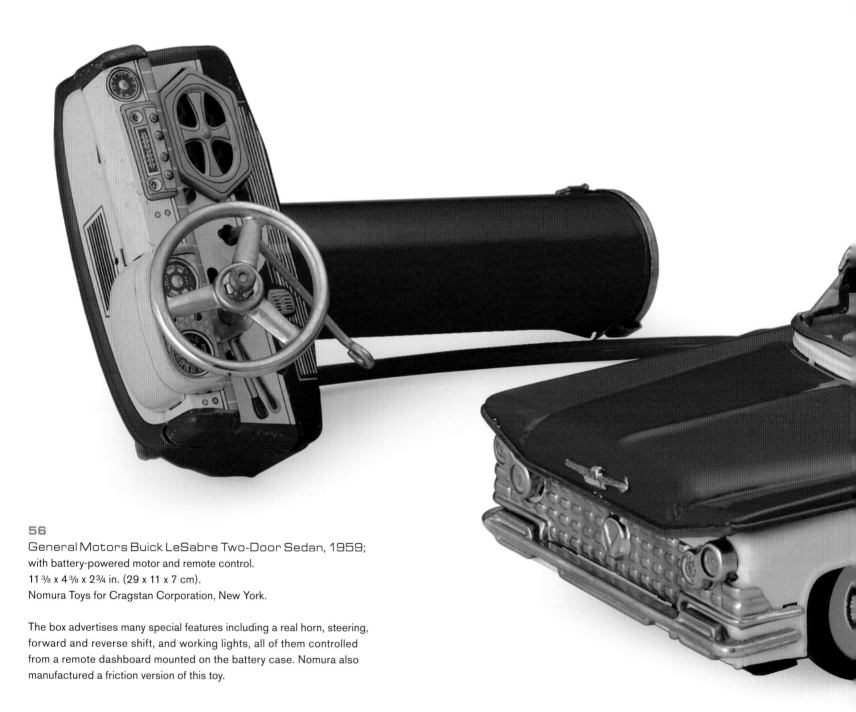

56

General Motors Buick LeSabre Two-Door Sedan, 1959;
with battery-powered motor and remote control.
11 3/8 x 4 3/8 x 2 3/4 in. (29 x 11 x 7 cm).
Nomura Toys for Cragstan Corporation, New York.

The box advertises many special features including a real horn, steering,
forward and reverse shift, and working lights, all of them controlled
from a remote dashboard mounted on the battery case. Nomura also
manufactured a friction version of this toy.

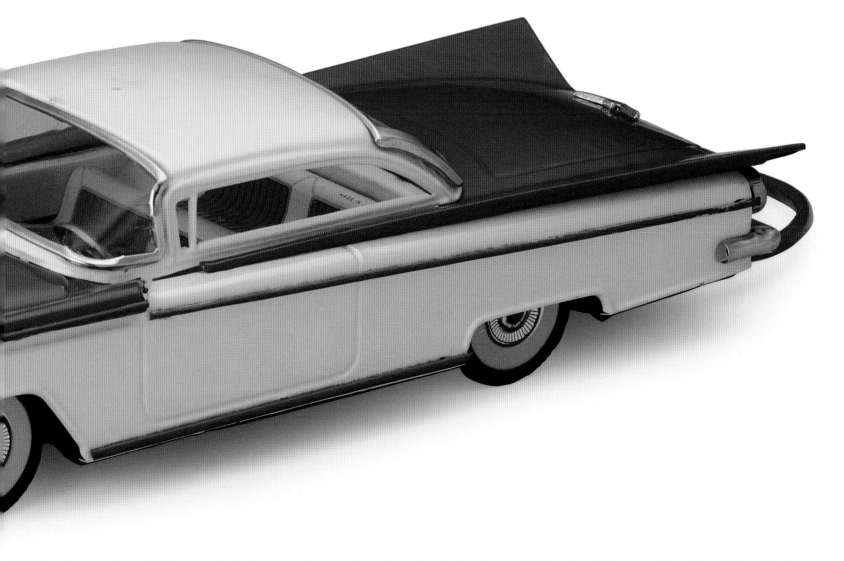

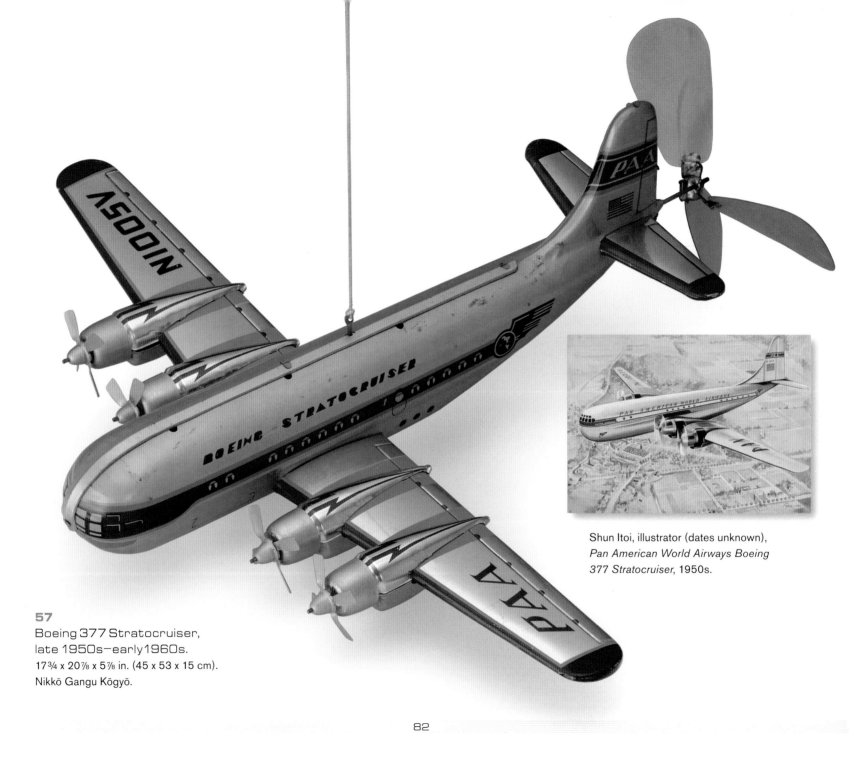

Shun Itoi, illustrator (dates unknown),
*Pan American World Airways Boeing
377 Stratocruiser*, 1950s.

57
Boeing 377 Stratocruiser,
late 1950s–early 1960s.
17¾ x 20⅞ x 5⅞ in. (45 x 53 x 15 cm).
Nikkō Gangu Kōgyō.

58

Piasecki H-21 Shawnee Transport
Helicopter, early 1960s;
with friction motor.
15 ⅜ x 3 ½ x 7 ½ in. (39 x 9 x 19 cm),
wingspan 5 ⅛ x 1 ⅛ in. (13 x 3 cm).
Nomura Toys.

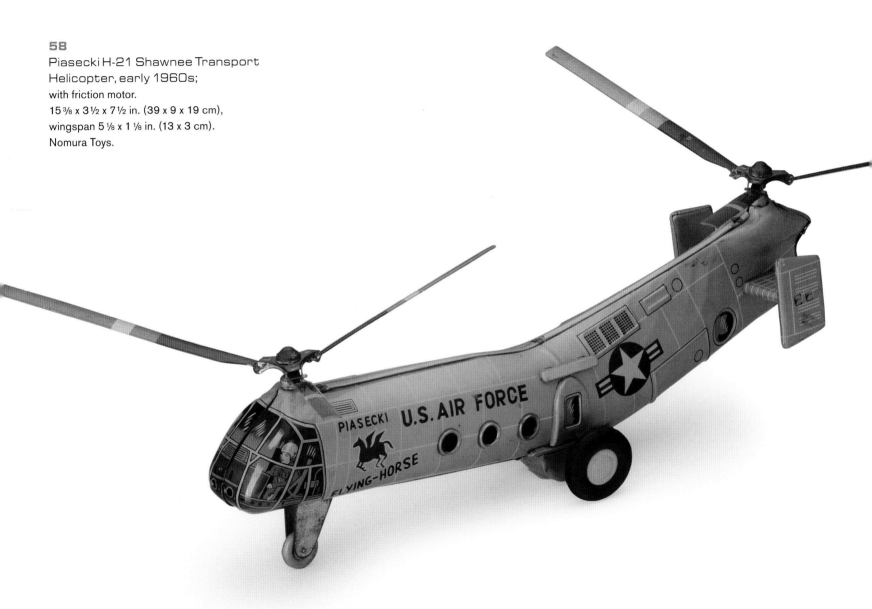

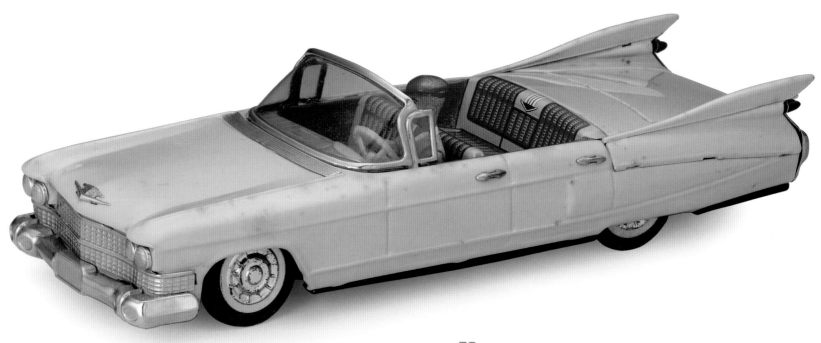

59

General Motors Cadillac Eldorado Biarritz Four-Door
Convertible, 1959.
11 ⅜ x 4 ⅜ x 3 in. (29 x 11 x 7.5 cm).
Alps Shōji for Rosko-Steele Inc.

The box bears the official seal of approval of "The Little Folks Creative
Guild"–a mark associated with other toys marketed by Rosko-Steele of
New York–and proclaims, "The new standard of the world in majesty.
Over one hundred models: Start your collection now!"

60

General Motors Cadillac Fleetwood
Special Four-Door Sedan, 1960,
converted for police use; with "Diamond"
radio control.
18½ x 6¾ x 4¾ in. (47 x 17 x 12 cm).
Yonezawa Gangu.

First marketed in 1955, radio-controlled
toys were being produced by several
manufacturers by 1960. Yonezawa also
brought out a 22½-inch, friction-driven
version of this model.

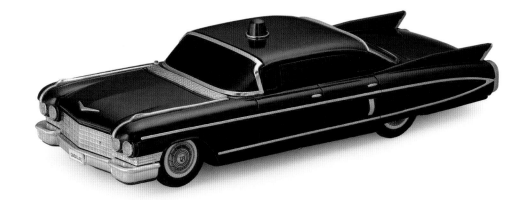

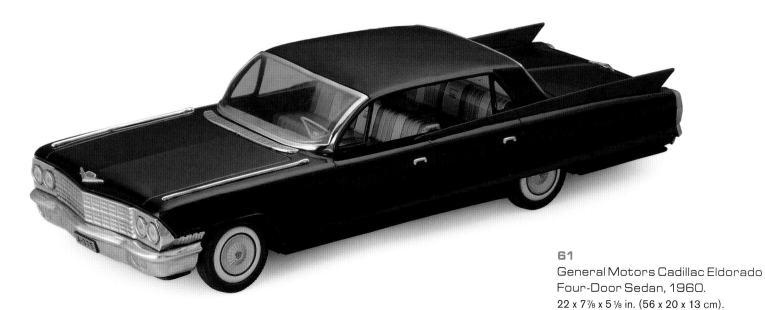

61

General Motors Cadillac Eldorado
Four-Door Sedan, 1960.
22 x 7⅞ x 5⅛ in. (56 x 20 x 13 cm).
Yonezawa Gangu.

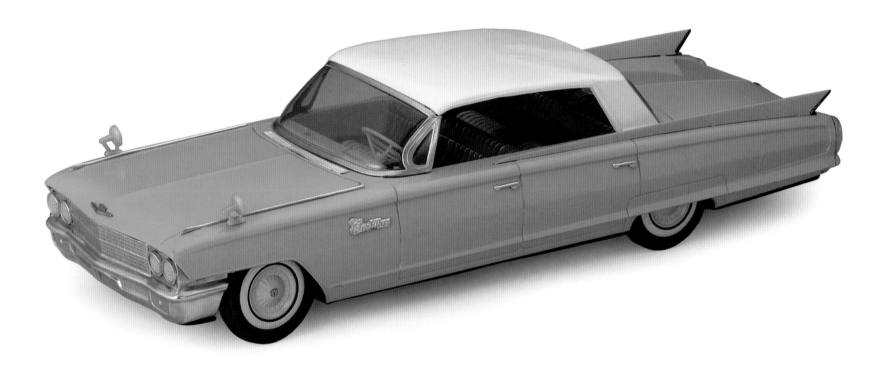

62
General Motors Cadillac Eldorado
Four-Door Sedan, 1960;
with friction motor.
19 ⅝ x 7 ⅛ x 4 ⅞ in. (50 x 18 x 12.5 cm).
Ichikō Kōgyō.

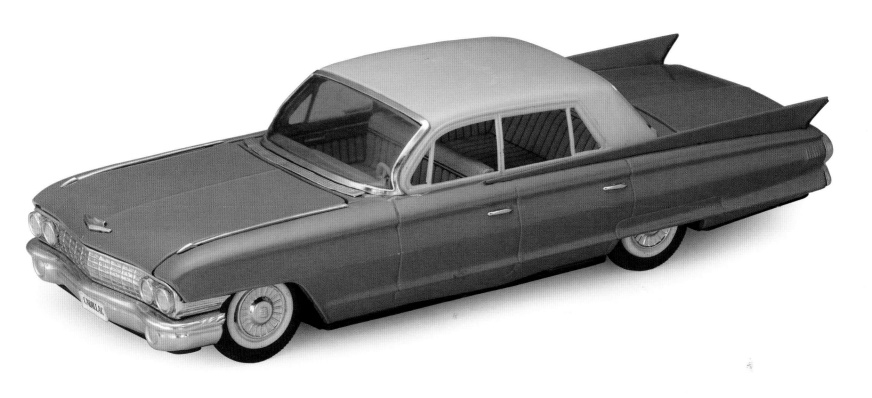

63
General Motors Cadillac Fleetwood
75 Four-Door Sedan, 1961;
with friction motor.
16⅞ x 6¼ x 4¾ in. (43 x 16 x 12 cm).
Shioji Shōten (SSS).

64

General Motors Buick Electra 225
Four-Door Hardtop, 1960.
17¾ x 6¾ x 4½ in. (45 x 17 x 11.5 cm).
Ichikō Kōgyō.

The glamorous Buicks of the late 1950s
and early 1960s were also modeled by toy
manufacturers in Brazil and Argentina, but not
to this high standard.

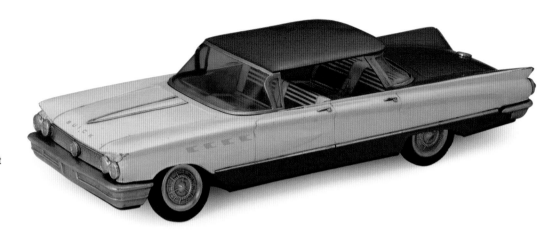

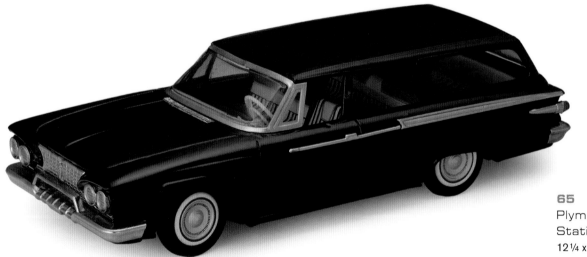

65

Plymouth Suburban Two-Door
Station Wagon, 1961.
12¼ x 4½ x 3⅜ in. (31 x 11.5 x 8.5 cm).
Ichikō Kōgyō.

This highly accurate toy includes the grille
guard that was only available on a limited
number of 1961 Plymouth models.

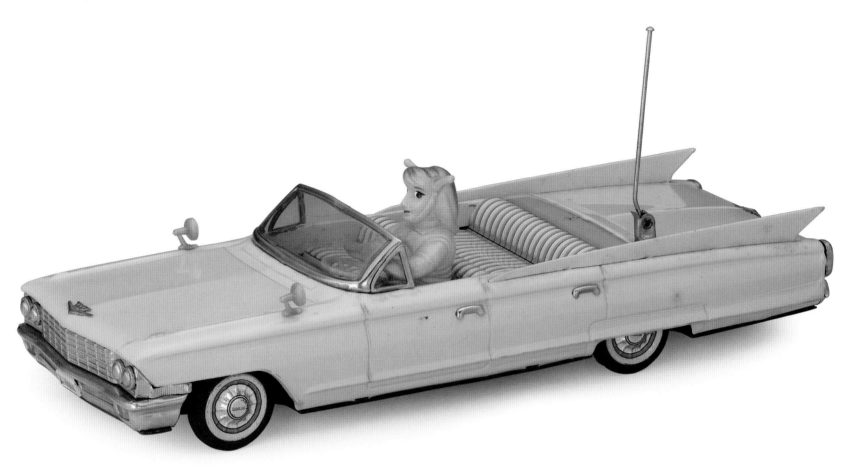

66

General Motors Cadillac Eldorado Biarritz Four-Door Convertible, 1962;
with Ambassador Magma.
14 x 4⅞ x 5⅞ in. (35.5 x 12.5 x 15 cm).
Yonezawa Gangu.

This car is driven by Maguma Taishi (Ambassador Magma), hero of legendary manga- and anime-artist Osamu Tezuka's story of the same name, which was published as a manga in *Shōnen Gekkan* magazine from 1965 to 1967, and as an animated Fuji Television series from 1966 to 1967. A stamped mark on the box (not shown here) indicates that it was manufactured with permission from Mushi Production Co. Ltd., an enterprise established by Tezuka in 1962. Since the toy is unlikely to have been first manufactured three years after the appearance of the real car, it seems probable that Ambassador Magma was added to an existing product in order to boost flagging sales at the end of the tin-toy era.

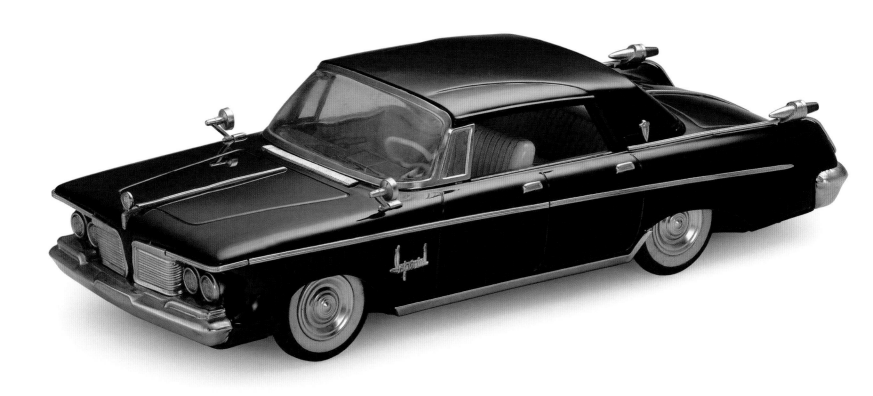

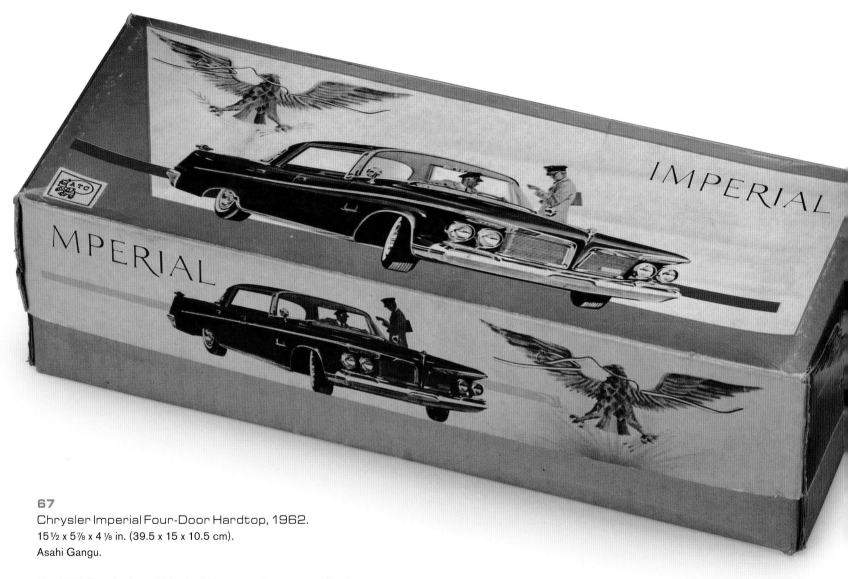

67

Chrysler Imperial Four-Door Hardtop, 1962.
15 ½ x 5 ⅞ x 4 ⅛ in. (39.5 x 15 x 10.5 cm).
Asahi Gangu.

The 1962 Chrysler Imperial by Asahi is among the most sought-after
of all Japanese tin-toy cars, particularly when accompanied by its
original box in fine condition.

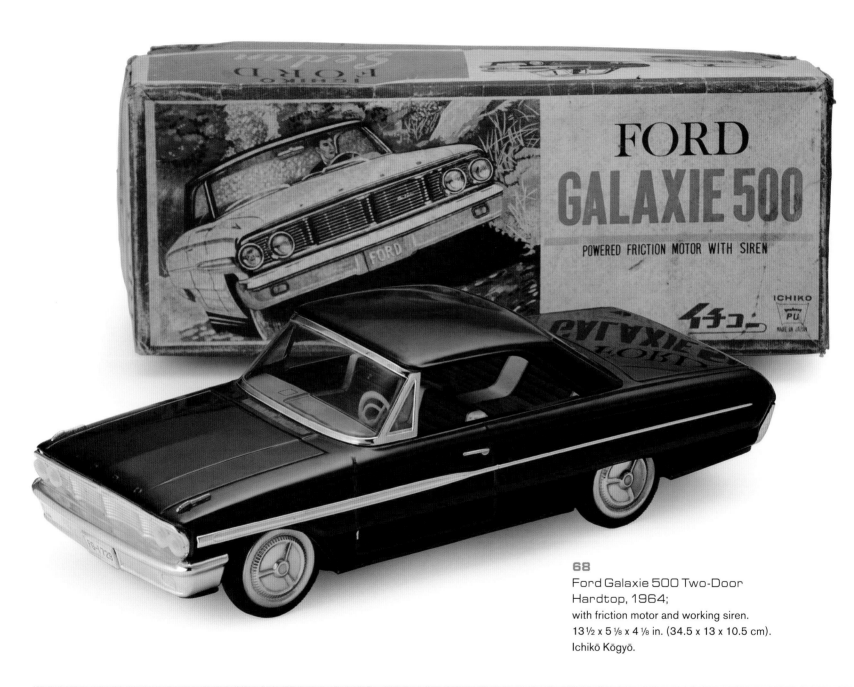

68
Ford Galaxie 500 Two-Door
Hardtop, 1964;
with friction motor and working siren.
13½ x 5⅛ x 4⅛ in. (34.5 x 13 x 10.5 cm).
Ichikō Kōgyō.

69

Concept sports car, early 1960s.
12 ¼ x 4 ⅛ x 3 ½ in. (31 x 10.5 x 9 cm).
Bandai.

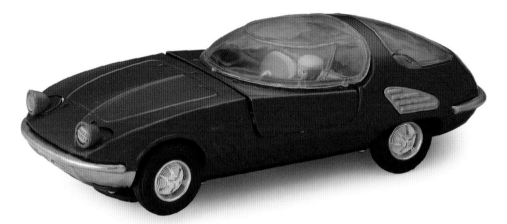

70

General Motors Chevrolet
Corvette Stingray Sport Two-Door
Coupe, 1963;
with battery-powered motor.
12 ¼ x 4 ¾ x 3 ⅞ in. (31 x 12 x 10 cm).
SKK Ichida.

The special features of this toy include opening
headlamps, "mystery with stop and go action,"
and a working horn. "Mystery," a word also
seen on the packaging for cat. 40, here refers
to a mechanism that allows the car to change
direction when it hits an obstacle, resulting
in an unpredictable, meandering series
of movements.

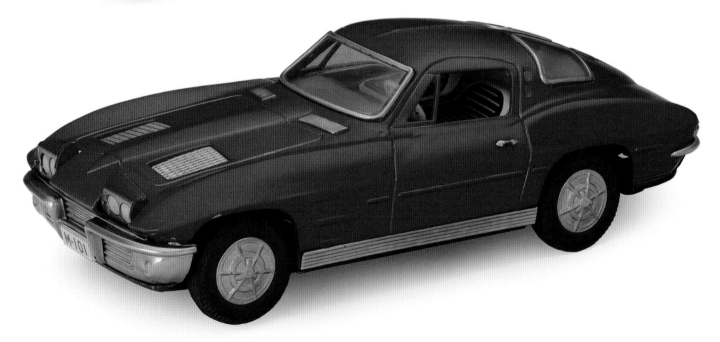

Friends of Japan Society Gallery

Honorary Chair
Her Imperial Highness Princess Takamado

Co-Chairs
Margot Paul Ernst
Masako Shinn

Director's Circle
Diane and Arthur Abbey
Edward and Betsy Cohen
Henry and Vanessa Cornell
Kurt A. Gitter, M.D., and Alice Yelen
Susan Hancock
Sebastian and Miki Izzard
Edward and Anne Studzinski
Yasko Tashiro and Thierry Porté
Chris A. Wachenheim
Jack and Susy Wadsworth

Gallery Circle
Shin and Maho Abe
Dr. and Mrs. Frederick Baekeland
Martin and Mary Ann Baumrind
Marc and Sara Benda
Raphael Bernstein
Marguerite and Walter Bopp
Rosemarie Bria and Sandy Levine
Henry and Gilda Buchbinder
Mary Griggs Burke
Alejandro M. Carosso
Beatrice Lei Chang
Dr. Carmel and Babette Cohen
Pilar Conde and Alfonso Lledo-Perez
Charles T. Danziger
Peggy and Richard M. Danziger
Thomas Danziger and Laura B. Whitman
Georgia and Michael de Havenon
Joe Earle and Charlotte Knox
The Esther Simon Charitable Trust
Martin and Kathleen Feldstein
Tom and Jody Gill
Alan and Simone Hartman
Dr. Gail D. Hashimoto
Mrs. Seiji Hatakeyama
Tomi Ise
Machiko Kashiwagi and Thomas Bingham

Mark and Elizabeth Levine
Dr. Stephen and Michiko Levine
Mr. and Mrs. John L. Lindsey
Rosemarie and Leighton R. Longhi
Dr. and Mrs. John P. Lyden
Dr. and Mrs. Robert W. Lyons
Joan B. Mirviss
Klaus F. Naumann
Marjorie G. Neuwirth
Halsey and Alice North
Wakako Ohara
Alex B. Pagel
Shelly and Lester Richter
Diane H. Schafer and Dr. Jeffrey A. Stein
Fredric T. Schneider
Lea Sneider
Mary Ann and Stanley Snider
David Solo
Erik and Cornelia Thomsen
Sachiko Tsuchiya
Mr. and Mrs. Cor van den Heuvel
Marie-Helene Weill
Roger L. Weston
Katsura and Mayo Yamaguchi
Anonymous (6)

Suggestions For Further Reading

Allison, Anne. *Millennial Monsters: Japanese Toys and the Global Imagination*. Berkeley and Los Angeles: University of California Press, 2006.

Anon. "Japanese Tinplate Cadillac Toys (1951–1964)." http://npbka.com/japanese-tinplate-cadillac.htm (accessed January 3, 2009).

Anon. "Marusan Kyaderakku sutōrii" (The Marusan Cadillac Story). In Akinori Shirai, ed. "Kitahara Teruhisa korekushon no sekai" (The Teruhisa Kitahara Collection). *Antiku toisu (Antique Toys)*, Geibun Mooks, no. 586 (May 2008): 67–79.

Burness, Tad. *American Car Spotter's Guide 1940–65*. Osceola, Wisc.: Motorbooks International, 1978.

Dower, John. *Embracing Defeat: Japan in the Wake of World War II*. New York: W. W. Norton and Company, 1999.

Fabulous Tin Toys, ed. "Tin Toys History and Sales of Toys and Dolls." http://www.fabtintoys.com (accessed January 3, 2009).

Gallagher, William C. *Modern Toys from Japan, 1940s–1980s*. Atglen, Pa.: Schiffer Publishing Ltd., 2005.

Kitahara, Teruhisa. *Kitahara Teruhisa no 20-seiki omocha daihakubutsukan (Teruhisa Kitahara's Great 20th-Century Toy Museum)*. Tokyo: Kōsaidō, 2001.

____. *Yesterday's Toys: Planes, Trains, Boats, and Cars*. San Francisco: Chronicle Books, 1989.

Kitahara, Teruhisa, and Yukio Shimizu. *1000 Tin Toys*. Cologne, Lisbon, London, New York, and Paris: Taschen, 1996.

Kumagai, Nobuo. *Buriki no omocha (Tin Toys)*. Tokyo: Green Arrow, 2000.

Langworth, Richard M. *Cadillac: Standard of Excellence, by the Editors of Consumer Guide*. Skokie, Ill.: Publications International, 1980.

Marusan-Toy.com, ed. "Marusan no rekishi" (History of Marusan). http://www.marusan-toy.com/home/index.html (accessed January 2, 2009).

Marusan-USA, ed. "Marusan History." http://www.marusan-usa.com/2295.html (accessed January 2, 2009).

Ralston, Andrew G. *Tinplate Toy Cars of the 1950s and 1960s from Japan: The Collector's Guide*. Dorchester, England: Veloce Publishing, 2008.

Saitō, Ryōsuke. *Shōwa gangu bunkashi (Toy Culture in the Showa Era)*. Tokyo: Jūtaku Shinpōsha, 1978.

Smith, Ron, and William C. Gallagher. *The Big Book of Tin Toy Cars: Commercial and Racing Vehicles*. Atglen, Pa.: Schiffer Publishing Ltd., 2004.

____. *The Big Book of Tin Toy Cars: Passenger, Sports, and Concept Vehicles*. Atglen, Pa.: Schiffer Publishing Ltd., 2004.